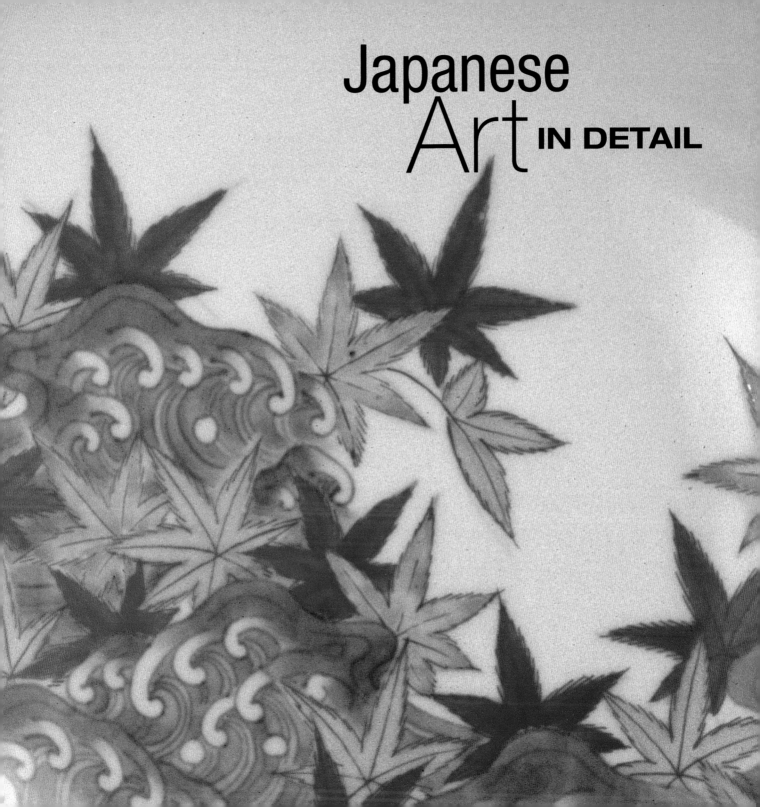

Japanese
Art IN DETAIL

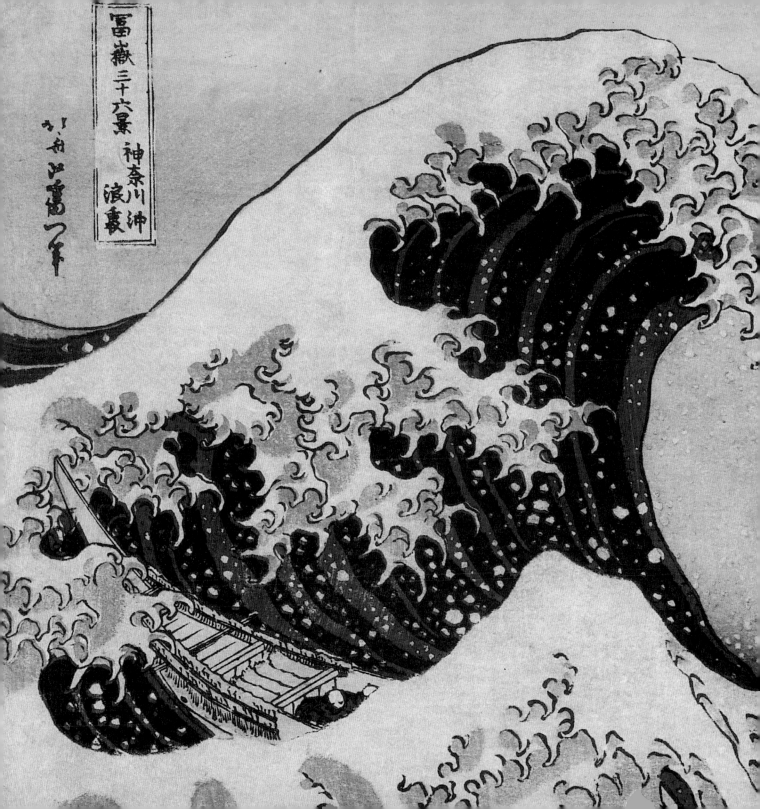

Japanese
Art IN DETAIL

John Reeve

HARVARD UNIVERSITY PRESS
Cambridge, Massachusetts

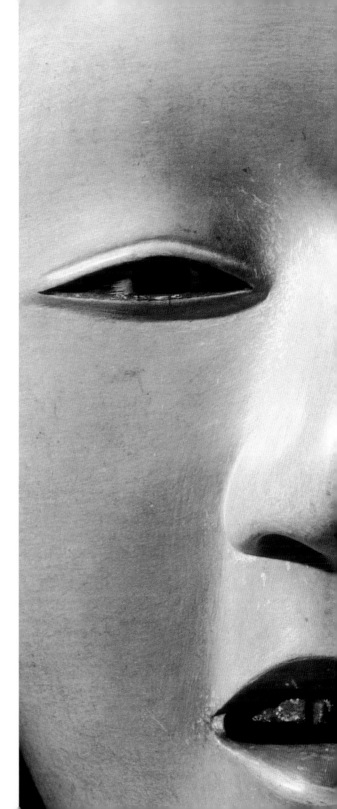

HALF-TITLE PAGE: Nabeshima ware dish, detail of maple leaves over a rushing stream, Edo period (see p. 51)

TITLE PAGES: Hokusai (1760–1849), The Great Wave, 1829–33 (see p. 96)

RIGHT: Nō mask of a young woman, painted wood, 18th–19th century (see p. 81)

Photography by the British Museum Department of Photography and Imaging

First published in 2005 by The British Museum Press
A division of The British Museum Company Ltd

John Reeve has asserted his moral right
to be identified as the author of this work

CIP data available from the Library of Congress

ISBN-13: 978-0-674-02391-8
ISBN-10: 0-674-02391-9

Designed and typeset in Minion and Helvetica
by Harry Green

Printed in China by C&C Offset Printing Co., Ltd

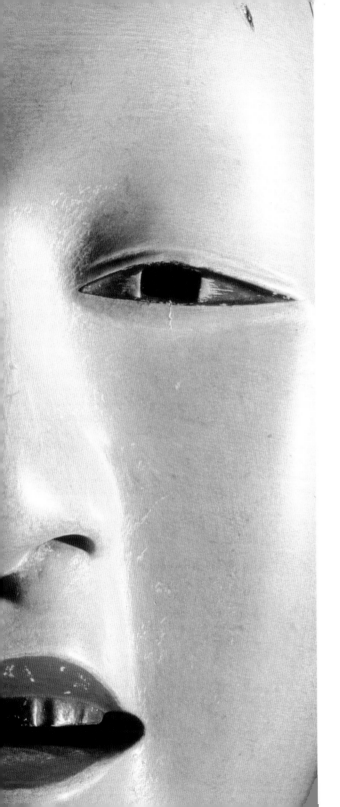

Contents

Preface

There are many books on Japanese art, so why another one?

This book is an introduction meant for anyone who is interested in looking more closely – no prior knowledge of Japanese art or culture is assumed. It is illustrated entirely from one extraordinary source – the British Museum – which holds one of the world's major collections, particularly of Japanese paintings and prints. The book is organised by themes rather than chronologically or by types of material, which are the more usual ways of approaching Japanese art. Turning these pages can therefore create surprising juxtapositions of paintings and lacquer, sculpture and prints, screens and netsuke, ancient and modern.

The Western concept of a permanent display is not a Japanese one, and indeed for conservation reasons even Western collections tend to rotate their prints, paintings and textiles. This is certainly true of the British Museum and its specially designed Japanese Galleries, in which changing displays are supported by a constantly growing permanent collection. The reading list in chapter 8 gives an idea of the exceptional scope of temporary exhibitions mounted in recent years. The British Museum does not specialize in textiles, furniture or folk art (mingei), so these do not feature in this book.

Most of the images reproduced here are accessible electronically on COMPASS, the British Museum's excellent online database, where additional works by other artists mentioned in the text as '(BM)' may also be found. There are also several online tours linked to recent exhibitions. In the captions are basic details of artist and historical period. Terms are defined in the glossary in chapter 8, where BM reference numbers for all illustrations are also listed. But this book is also designed to be used with any Japanese collection, and online links to many others are given in chapter 8. For the purposes of looking closely, the specific objects pictured here could be seen as representative of many others in other public and private collections world-wide.

Modern and contemporary Japanese artists continue to draw on old traditions and familiar

subject matter while making imaginative use of all the tricks of new global technologies and styles. A vivid silkscreen by contemporary artist Ay-O has a sumo subject and is based on an eighteenth-century woodblock print (see chapter 4, p. 92), while Satoru Matsushita (b.1957) creates in 'Summer Time-2', 1984 (BM) a tribute to David Hockney's familiar images of California swimming pools. Artists and designers do not see tradition as innately constricting: 'If the craftsmen and designers of old Japan could create beauty with their materials, are we today to accept defeat when faced with ours?' asks designer Hideyuki Oka. Other traditionalists have despaired of modern Japanese culture, 'the compromise culture of today' as novelist Yukio Mishima put it. Very conscious of his samurai origins, Mishima felt Japan had gone soft from years of peace after its defeat in the Second World War, and that 'one may neither live beautifully nor die beautifully'. He committed suicide by seppuku in 1970 after failing to rouse soldiers to revolt.

This book begins with some of the characteristic forms of Japanese art –

woodblocks, ceramics and lacquer. Also featured throughout are paintings and sculpture. The first and last themes are serenity and turmoil, the two poles of Japanese culture ancient and modern, which frame chapters on nature and pleasure, landscape and beauty. The turmoil – personal, social and cultural – continues, finding new outlets for expression in a new century through artists, architects, designers, novelists and film-makers, and increasingly video, performance and installation artists, who have become a particular strength of contemporary Japanese art.

I would like to thank Nina Shandloff of BM Press for inviting me to write this book, and for all her help, Harry Green for its elegant design, Jerome Perkins, John Williams and Kevin Lovelock of BM Photographic and Imaging for supplying the illustrations, Mavis Pilbeam of the Japanese Section in the Department of Asia for her constant help and encouragement, and Tim Clark of the same Department for his advice and encouragement over many years.

This book is for my father.

1

What is Japanese art?

OPPOSITE

Nō mask of an old man.

Japanese art is often immediately recognizable: the celebrated views of Mount Fuji by Hokusai, the female beauties of Edo and images of the natural world by Utamaro, or the evocative landscapes of Hiroshige. All these artists are represented in this book, but so are many far less familiar names: earlier artists and later ones from the 19th and 20th centuries; and others from the 18th century onwards who specialized in depicting the world of pleasure, sometimes astonishingly frank, and unlike anything in Western art at the time. The formats, conventions and style of these Japanese woodblock prints, paintings and screens, of calligraphy and kimonos, Zen gardens and kabuki theatre, came as a breath of fresh air to Europeans and Americans from the later 19th century. Artists such as Manet and Degas, Toulouse-Lautrec and Bonnard found liberation in Japanese art from the conventions of the West. They admired an elegance of line; strong, flat blocks of colour; and very different ideas on perspective and composition. These artists collected Japanese art, fans and screens, and prints of life in Edo. They too depicted modern life, and particularly pleasure, rather than history or mythology: in their case the world of the nightclub, the bar, the races, the brothel and the ballet. Composers such as Debussy and Britten have also been inspired by Japan, as have architects and designers including Frank Lloyd Wright.

Compared with most countries, traditional culture is still remarkably intact and respected in 21st-century Japan – its craft skills, theatre and music, temples and rituals. One reason for its survival is the Japanese ability to fuse the new and the old, the innate and the imported (see, for example, Ay-o's sumo wrestlers, p. 92). Alex Kerr, an American writer who has lived there for many years, speaks of Japan being like an oyster, miraculously transforming its raw materials. As one Japanese writer put it in 1940: 'Ours is destined to be the country where, as modern history shows, new and old, high and low, East and West, make their contact day by day.'

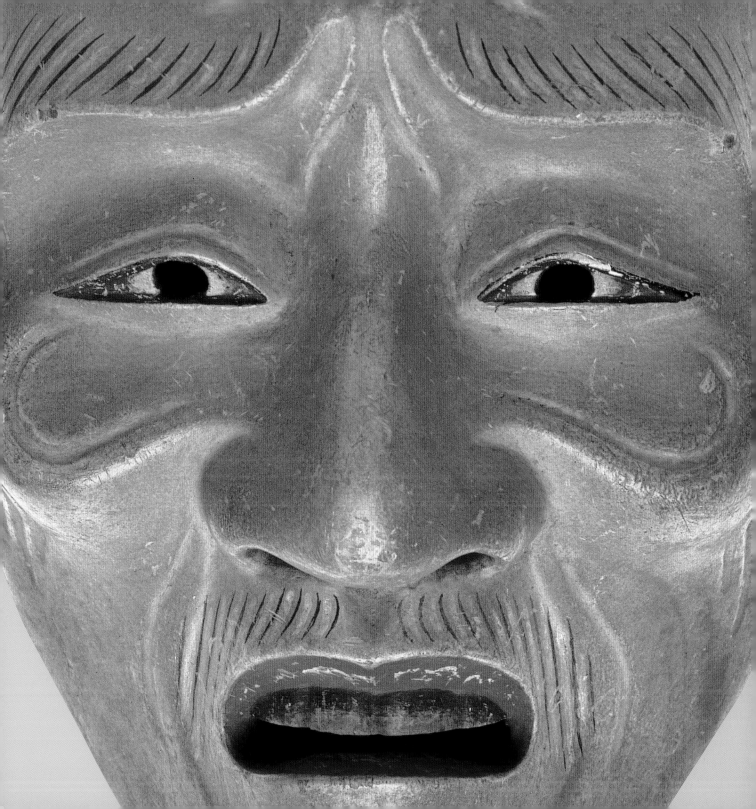

Woodblock prints

Many of the illustrations in this book are of woodblock prints. Making such prints was a process involving several people. The artist – in this case Yoshitoshi – drew his designs on paper like this one, and the final one was then glued back to front on to a wooden block, preferably made from cherry wood. At that point craftsmen took over to cut the blocks and to ink and print them on mulberry paper. The British Museum collection includes blocks for prints by Masanobu from *c*.1710.

Tsukioka Yoshitoshi (1839–92), Empress Jingu leading the invasion of Korea, preparatory drawing for a colour woodblock print. Meiji, 1879.
Yoshitoshi worked during the years after the restoration of the Meiji emperor, when Japan began to adopt some aspects of Western dress, technologies and ideas, including in the arts. One of his striking, almost cinematic prints is illustrated on pp. 132–3. On this drawing we can see the lines where he made final changes, and also where he has added extra pieces of paper.

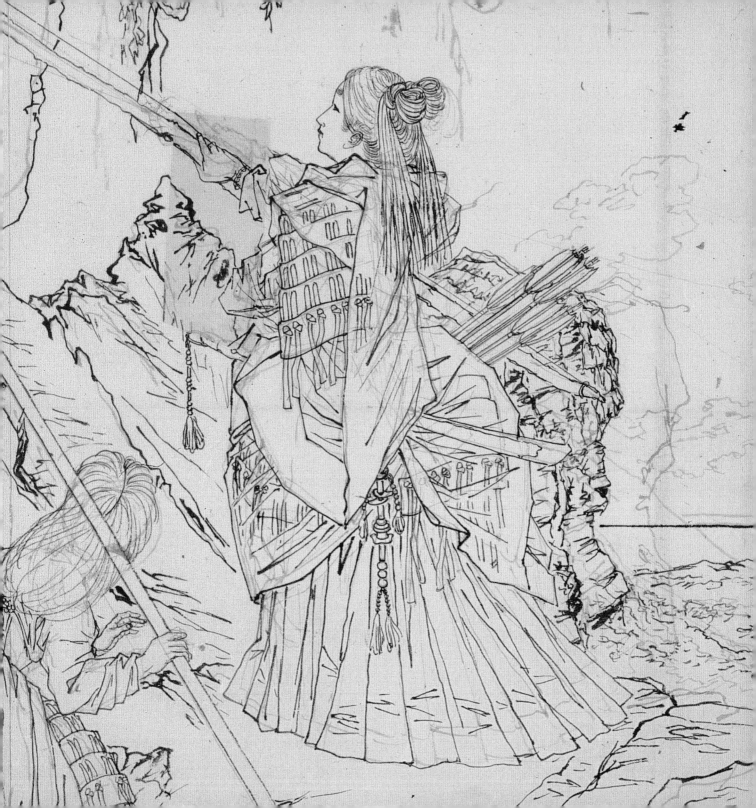

Utagawa Kunisada (1786–1864), Imaginary scene of women producing woodblock prints, a triptych of colour woodblock prints. Edo, 1857.

This is only imaginary because women rather than men are shown at work here. They are cutting through the drawing on to the block (right-hand panel), cutting the block and preparing the paper (centre). The colours (left-hand panel) were not mixed to produce shades, as in Western art, but used as uniform blocks, strengthened or darkened by adjusting the amount of water or white pigment. For each colour the paper was aligned on to separate blocks, often from ten to twenty in number. Great skill was needed to make sure that all these colours printed out precisely without blurred outlines or overlaps. Prints might be on single sheets, two, three or even six sheets. There were regularly 200 impressions to one edition, which could be one week's work for a printer. Works by popular artists like Hokusai or Hiroshige might require as many as 10,000 impressions, at a time when a colour print cost the same as a bowl of noodles.

Some artists were extraordinarily prolific: Kunisada (see pp. 114–15) produced over 50,000 designs, while a prolific Western artist of the same era, like Daumier, managed up to 8,000. Some artists such as Sharaku and Goyō produced far fewer prints: Goyō published only 13 designs in the 1920s (see p. 117), and Sharaku, famous for his actor prints, appears to have worked only for 10 months in 1794–5 (see pp. 86–7).

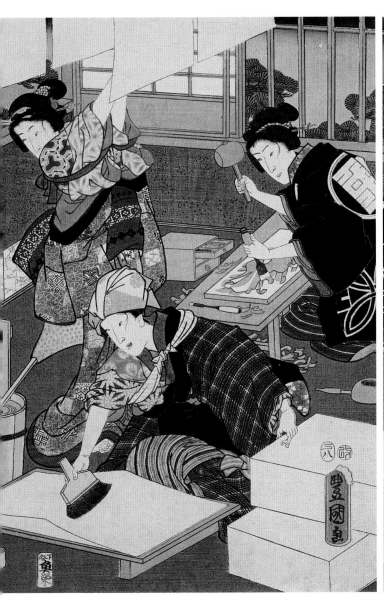

Kubo Shumman (1757–1820), 'A Party in the Four Seasons Restaurant by the Sumida River, Edo', a diptych of colour woodblock prints. Edo, *c.* 1786.

This pair of woodblock prints is all about pleasure and consumption in Edo, the old name for Tokyo, and then one of the world's biggest cities. Edo inspired a special type of urban art, such as this print of people at a party in a section of the city devoted to pleasure. Nearby were theatres and brothels. It appeared in the 1780s, at a time when urban Japan was prosperous, at peace and largely cut off from the West.

Shumman was a poet as well as a prolific painter. He specialized in showing elegantly dressed women, and used vivid colours: in this print there are strong reds, purples and blues, with bright yellow for the woodwork. These are not necessarily meant to reflect accurately the colours of the real world. They are still vivid today, except for the blue of the river. Only from *c.* 1830, with the availability of Prussian Blue, did printmakers have access to a blue that did not fade. Hokusai's 'Great Wave' dates from that year and demonstrates this new colour (see pp 96–7).

The Four Seasons restaurant was very popular, famous for its highly original fish cuisine, and attracted varied ranks of society. In the restaurant garden, flowers of the four seasons were supposedly seen in bloom all year round. Shumman's image (see pp. 16–17) is full of detail: inside the restaurant stand one pair while another play a game. Arranged in different poses on the reed matting we can also see two geisha tuning up their stringed shamisen. Tea is being served, and raw fish are brought in on a tray. Outside there are lanterns, boats on the Sumida River (perhaps bringing more customers?) and a distant view of the city, including a lookout tower to watch for fires – essential with such combustible wooden buildings.

All the elements of this composition are framed in an unusual way and cropped (particularly the trees) as if glimpsed from elsewhere in the restaurant, or from the outside. The composition is built on strong diagonals: low fences, the riverside, rows of warehouses and other buildings on the other side. The diagonals give the space great energy: Japanese prints are seldom static. To help create this effect, the artist has eliminated the sliding screens from the corner and side of the room facing the river, so we can see how it opens directly on to a verandah extending all the way around the building. Renoir's 'The luncheon of the boating party' in the Phillips Collection, Washington, DC, makes a useful comparison with this print. Renoir also uses diagonals, arranging his partygoers as if to invite us into the painting's space and to interact with its web of conversations and glances. He crops bodies and space in a similar way to Shumman, creating a feeling of intimacy and activity.

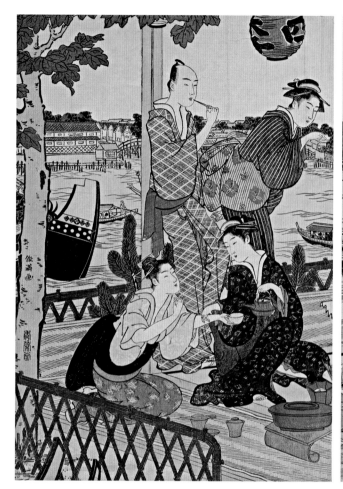 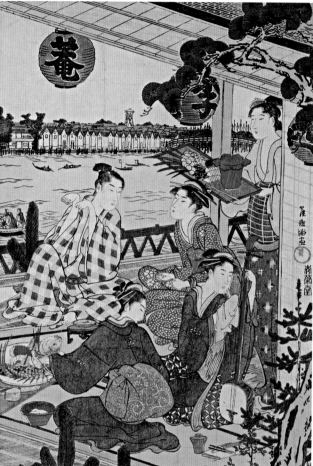

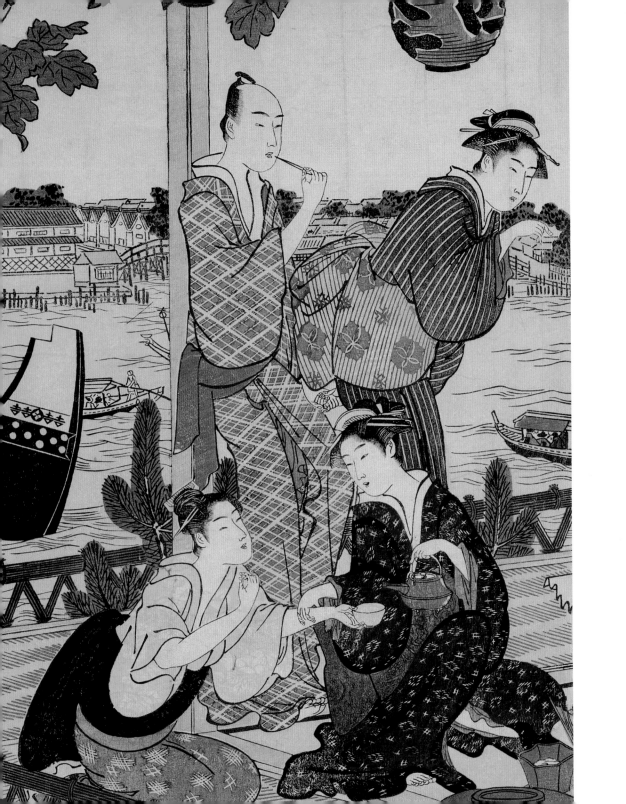

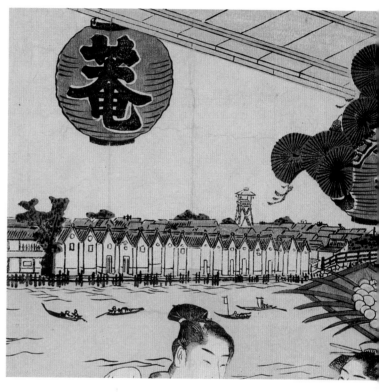

These details emphasize how Shumman has framed the print, for example, by cropping the tree and the boat. Tea is served as customers wait for food, to be accompanied by geisha who tune their shamisen. We have a glimpse across the river at Edo itself, a densely packed and combustible metropolis, overlooked by watch towers.

Ceramics

**Two haniwa figures, pottery. Kofun, 6th c. AD.
The female figure (left) is 55 cm high, sports
an elaborate hairstyle and wears a string
of beads. The male figure (right) wears
distinctive trousers and hat reminiscent
of the American Wild West.**

Japan has the oldest ceramic tradition in the
world, dating back at least to 10,000 BC, and this
tradition is still flourishing. Technical skill and the
desire to decorate were evident from the
beginning. As in China, a centralizing Japanese
state swallowed up smaller powers and displayed
its conspicuous consumption in art and building,
especially for the dead. These figures from the
Kofun period, like the Chinese terracotta army
and other grave figures, are a mark of respect for
the powerful departed and their heirs.

Haniwa are coiled cylindrical pots that have
been partly animated – as people, but also as
birds, cows, horses and houses – to create an

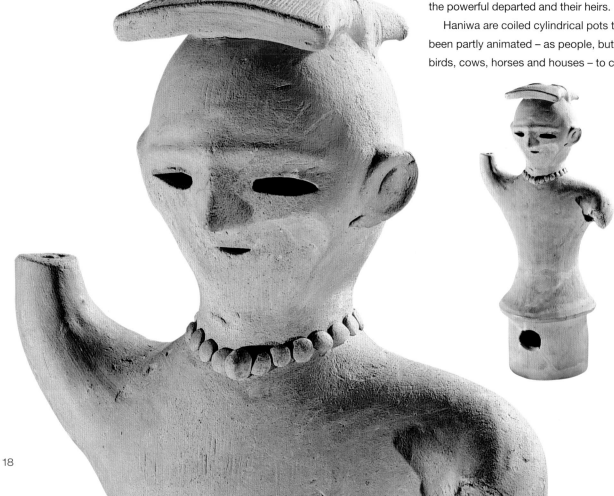

instant court for the deceased. Large numbers
of these haniwa were made, unglazed, at great
speed, sometimes in thousands. If there was
time they might be painted in red slip. They
stood clustered on top of, or around the entrance
to, a giant keyhole tomb, or on a bank beside it.
Such tombs survive, for example, in Osaka,
where haniwa kilns have been excavated.
The largest tomb was nearly 30m high, over
500m long and had three moats, built for a
5th-century emperor. This tradition (AD 250–600)
came to an end with the arrival of Buddhism.

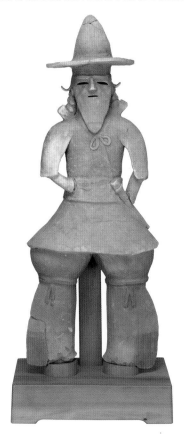

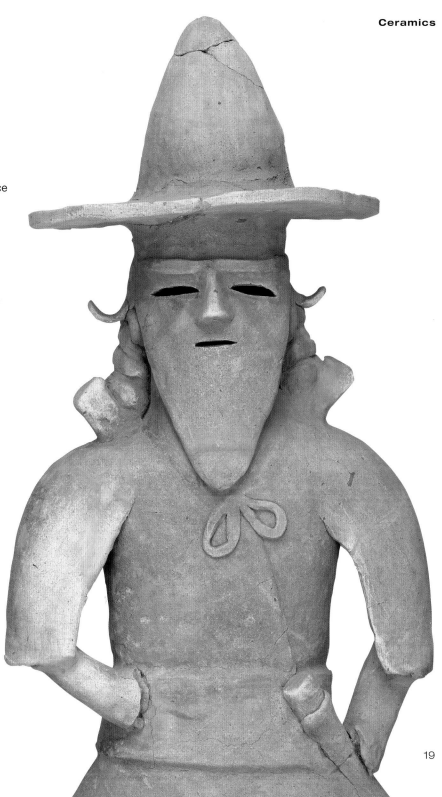

**Keiko Hasegawa (b.1941),
ceramic water jar, 1980s.**
Crucial innovations from China and Korea have often been subsumed into a Japanese aesthetic, as with Tea Ceremony wares (see pp. 35–6) and porcelains from factories at Arita such as Kakiemon, with its fresh depictions of nature (pp. 50–53). Contemporary potters can be utterly distinctive, whether based in Japan or abroad.

Just as actors often follow in a long line of acting ancestors, so may artists. Keiko Hasegawa comes from a family in Japan who have worked with cast iron for over fourteen generations; her raku pieces have a strongly metallic finish. She now lives in Britain, where she has worked since the 1970s – initially with the son of the potter and writer Bernard Leach, who did so much to relate Western and Japanese ceramics to each other.

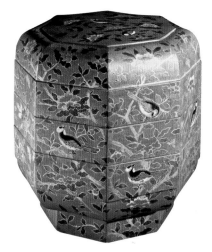

**Octagonal nest of boxes for food.
Red and gold lacquer, Ryūkyū Islands.
Edo, 17th century.**
This is an especially rich example of lacquerware from Japan's most southwesterly islands. Originally lacquer was a protective covering – its natural resin made wooden and other objects waterproof – but it soon became an art form. Lacquer accessories complemented textiles, and there are many exquisite examples (see pp. 40–41, 54–7, 64).

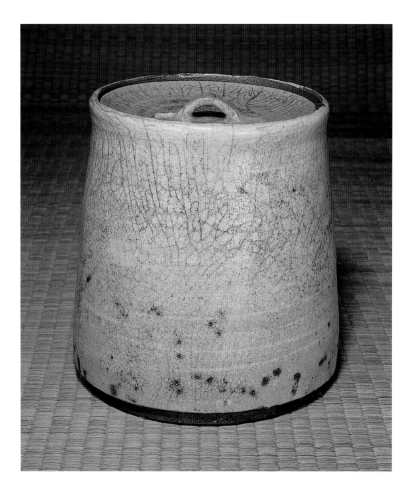

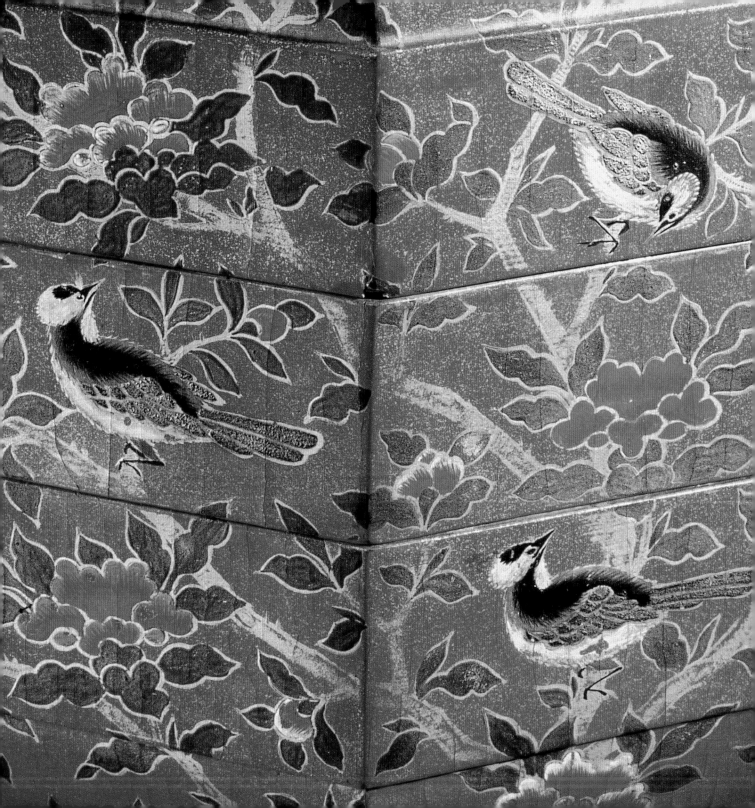

2

Serenity

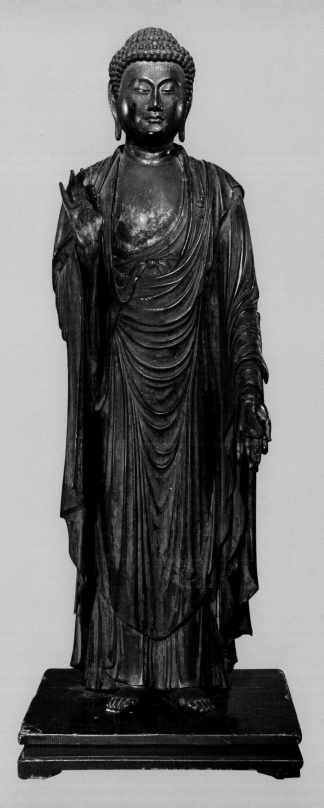

Serenity and turbulence, spirituality and slaughter have often gone hand in hand in Japanese culture. 'The chrysanthemum and the sword' was the phrase Ruth Benedict used, immediately after the Second World War. The same might of course be said for ancient Greece, for Gothic or Renaissance Europe, or the age of Frederick the Great. In Japan the samurai warrior, with his lethal sword and razor-sharp reactions, was also the writer of poetry, patron of the Tea Ceremony and connoisseur of calligraphy. This duality is reflected especially in the arts of Buddhism, which have played a key role, along with Shintō, in defining Japanese aesthetics. Japanese art, like Japanese religion, can provide an assurance (or illusion) of calm while also honestly reflecting the turbulence of life both outside and within (see chapter 7). This Buddhist sculpture comes from the Kamakura period (1185–1333) when a military regime ruled Japan from the most easterly of its capitals, a decisive shift away both from the emperor and his court and from Kyoto. A giant bronze Buddha survives at

Kamakura near the seashore and reflects the authority of the regime and its art. Kamakura encouraged a more open, popular Buddhism, of the streets and temples rather than of the enclosed and refined royal court. A wooden head of the Buddha one metre tall, also from this period (BM), suggests a giant figure of the kind familiar from Buddhist temples such as the Tōdaiji in Nara. Sculpture of the preceding Heian dynasty (794–1185) did show the fierce side of Buddhism (see p. 126) but more often a softer side, as in the figure of Kichijōten, female deity of fortune (BM).

The figure of Amida is usually part of a triad, including also Kannon, known in India as Avalokiteshvara, who hears the sufferings of mortals on earth below. After a lavish figure of Kannon we look at a Zen ink painting, an example of lay Buddhist art, and two highly expressive images of moments in the life of the Buddha himself. We end by considering the Tea Ceremony, which brings together many different media and sensations in the pursuit of serenity.

The Buddha Amida, wooden sculpture. Kamakura, 13th century.
This Buddha commands attention, like the imposing stone Buddhas from Chinese cave temples. Amida, Buddha of Everlasting Life, is a previous incarnation of the historic Buddha: whoever invoked his name believed they would be granted an eternal life of happiness in the Pure Land (known as the Western Paradise in Chinese art). Wooden images like this were usually covered in white gesso, lacquered, painted and then gilded in order to be visible in a dark interior. The hands, as usual in Buddhist art, express a message: here they welcome the devout to paradise.

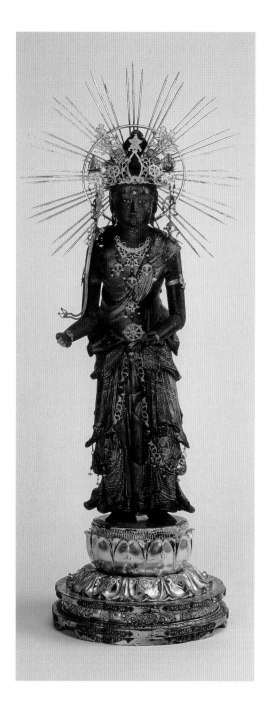

The bodhisattva Kannon, gilded wooden sculpture. Kamakura, 14th century.
Kannon is one of the triad who welcome the faithful into the Western Paradise. There is a sense of welcoming in the pose of this richly gilded figure, bending forward, unlike the stance of the more remote, authoritative figure of Amida (pp. 22–3). As so often in Chinese-style Buddhist art, the figure is androgynous, potentially offering the best of both worlds. It is festooned with jewellery – the faithful would also add more – and stands on a stylized lotus. The faithful might reach paradise on a lotus; the Buddha also used the white lotus as a metaphor for a Buddhist life born in the mud of everyday temptation and squalor, but which can eventually burst from its long stalk into pure flower, like a devout Buddhist reaching Nirvana.

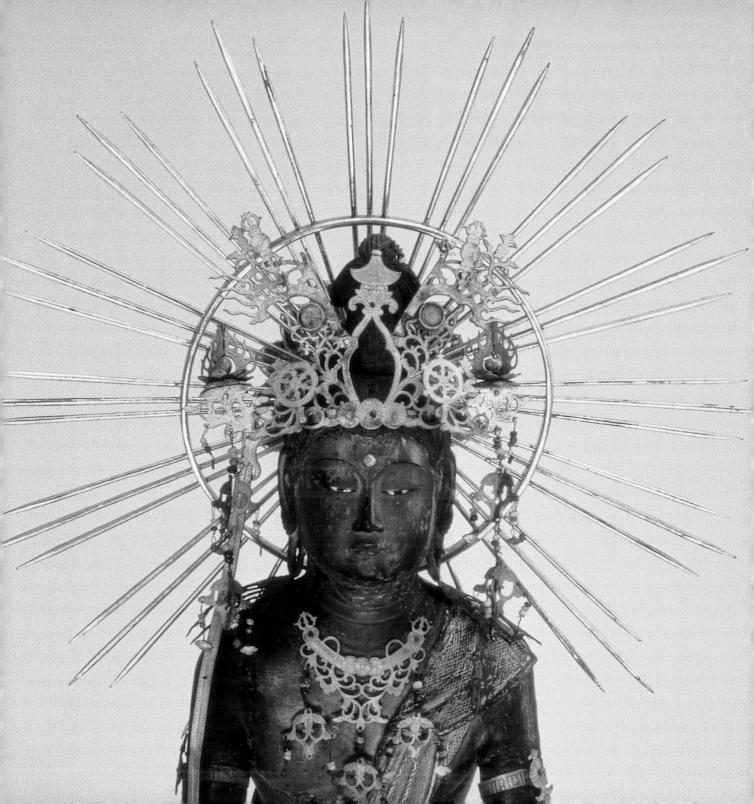

There are many schools and styles of Japanese Buddhism. The founder of Zen Buddhism was Daruma (in Japan; Bodhidharma in India). He was an Indian guru who died around AD 532 after taking his teaching to China. From there Zen spread to Japan in the late 12th and 13th centuries where it became enormously influential, appealing in particular to the samurai warrior. The emphasis in Zen is on meditation, to focus the mind and sharpen the wits, rather than on the study of texts or elaborate ritual. Hanging scroll paintings like this one were not intended for permanent display – they were usefully portable in a society on the move, and could be brought out for contemplation on special occasions. This is therefore a concentrated image with no distracting details: a forceful role model of spiritual power.

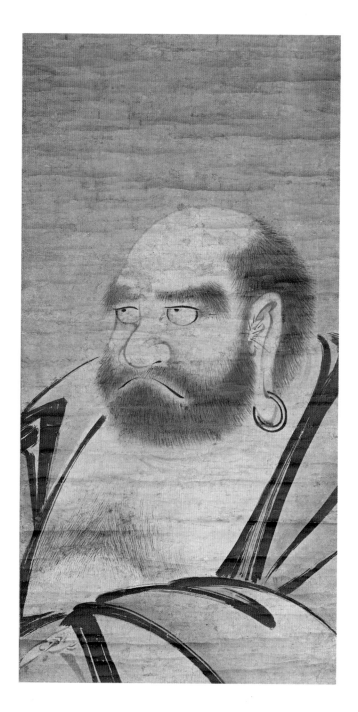

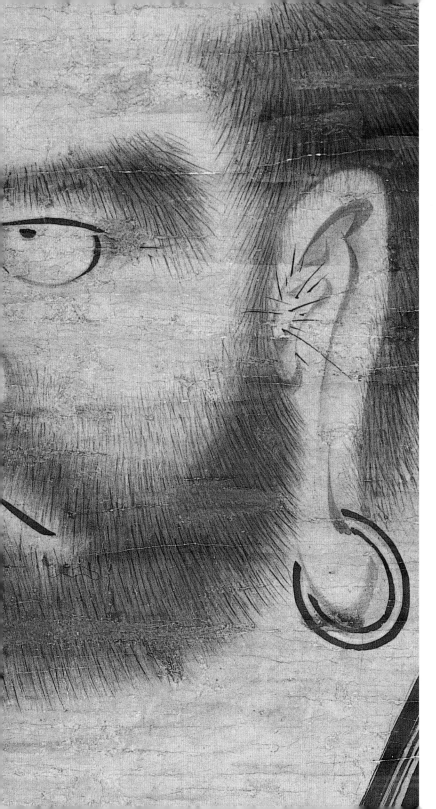

Daruma (Bodhidharma), ink painting on hanging scroll. Momoyama, 16th century.
Daruma is depicted as hairy in order to show that he is foreign – providing an opportunity for the artist to apply ink with calligraphic refinement to create hair, whether over the paunch or in the ears (see also the fur on monkeys by Mori Sōsen, pp. 60–61). Daruma is said to have spent nine years meditating in a cave and so lost the use of his arms and legs. He also cut out his eyelids so he couldn't sleep, hence the strong black line where eyelashes would normally be. He is familiar in Japan today as a red spherical doll without arms or legs, whose eyes are painted in later – one to bring luck at the beginning of a project (an exam or election) and the other at its successful end. At New Year, old Daruma dolls are burnt at the local temple and new ones are purchased, to bring luck in the year ahead.

A 13th-century Chinese poem describes him:

> His eyes are like meteors
> He flashes like lightning
> A death-dealing knife,
> A life-giving blow.

> Hui-k'ai, 'The Gateless Barrier'

**Retired townsman in Buddhist robes,
lacquered wooden sculpture. Edo,
late 17th–early 18th century.**

This statue reflects the piety of the growing
bourgeoisie in cities such as Edo (modern Tokyo)
at this time. Although only 40cm high, the
sculpture has considerable power and conveys
vividly the serenity and concentration of an
elderly lay Buddhist.

There is a tradition throughout Buddhist Asia
of lay people, young and old, spending time in
monasteries and retreats. They also maintain an
active relationship with their local shrines and
temples as a regular part of daily life by making
offerings, giving food to monks, and visiting
regularly to pray and reflect, creating a small
oasis of serenity in the midst of the hectic city.

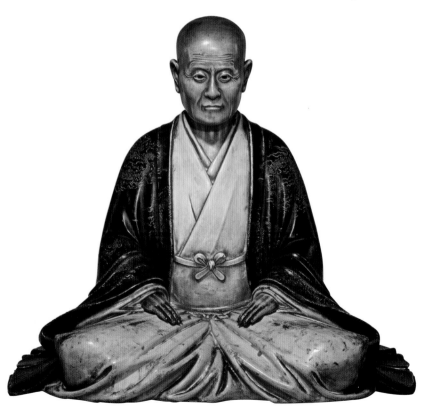

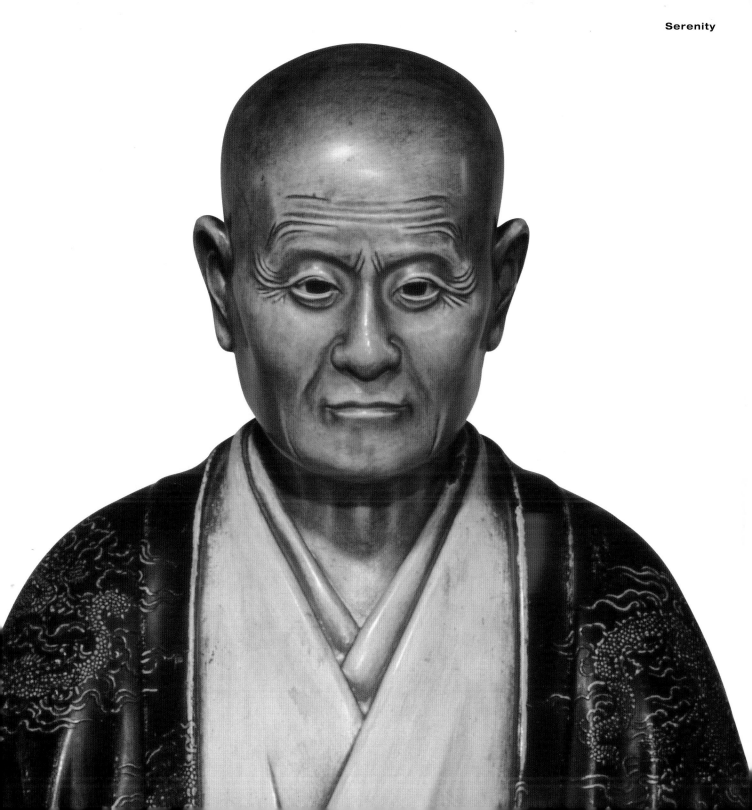

Shaka, gilt and lacquered bronze sculpture. Edo, AD 1630.

Having renounced his life as a prince, the future Buddha fasted for six years and became emaciated, later describing how his flesh hung on his bones, the veins stood out on his forehead and his eyes were sunk as deep as wells.

The Edo sculptor captures this beautifully in this statue commissioned by an abbot. We can imagine it glowing in the semi-darkness, possibly in a private shrine, a mixture of black and gold, pain and transcendence. It was consecrated in 1630 on the anniversary of the Buddha's death. Only after his experience of suffering, as shown here, did Shaka find enlightenment, becoming the Buddha ('the Enlightened One'). He renounced both the extremes of his life in favour of the Third Way.

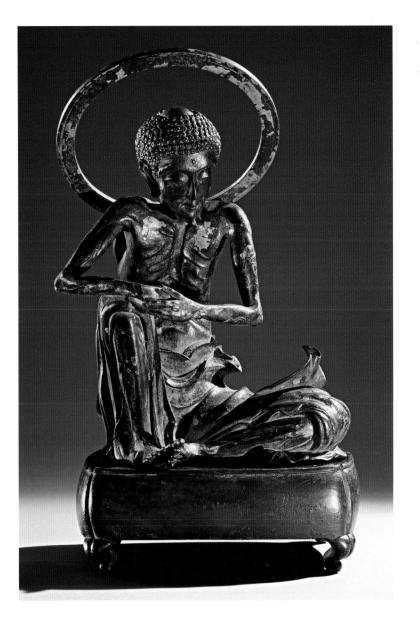

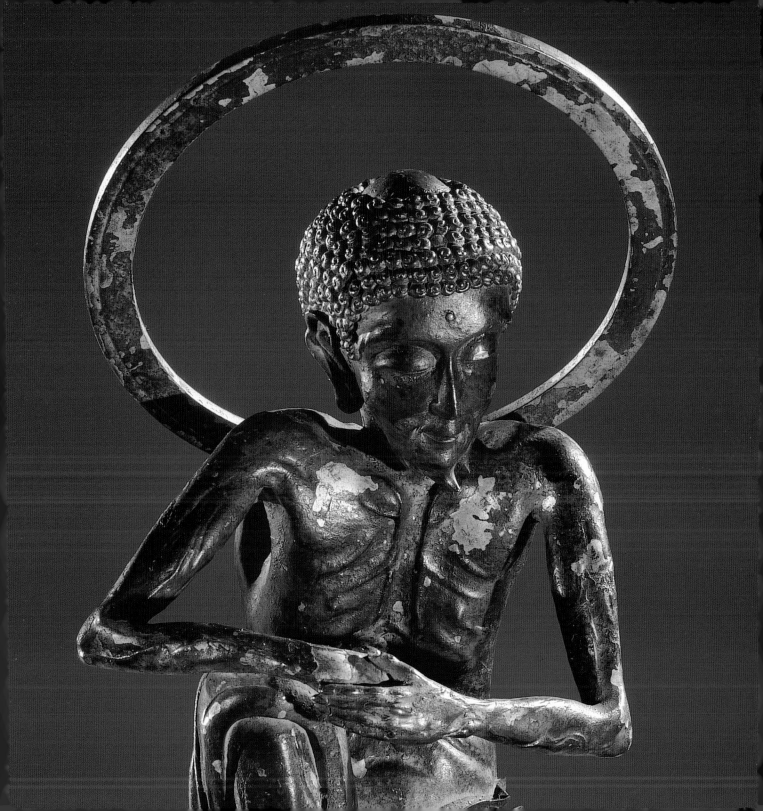

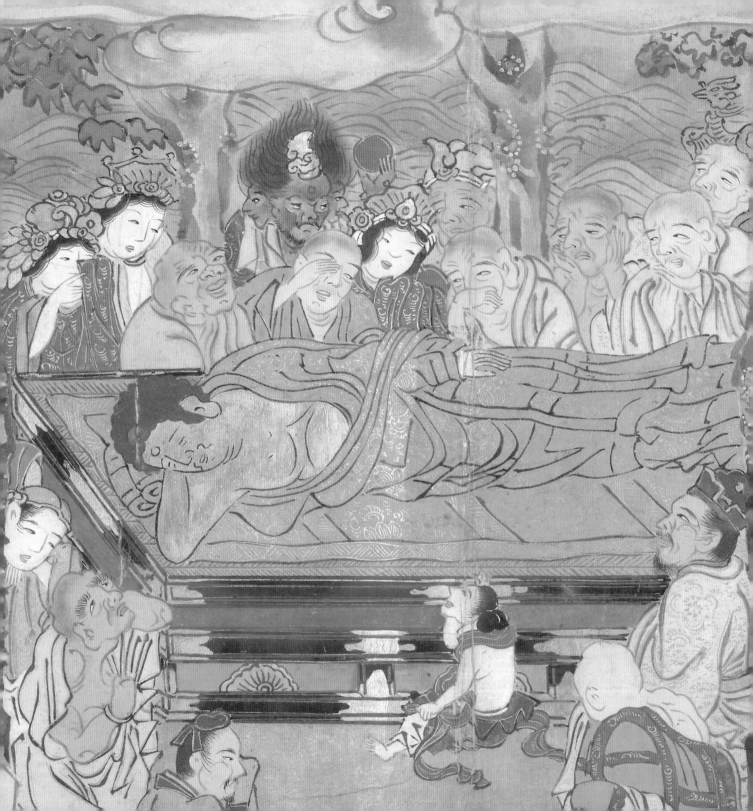

**Death of the Buddha (Parinirvana),
detail from a handscroll. Edo, 17th century.**
The commemoration of the Buddha's death,
or rather his ascent to Nirvana, is the climax of
the Buddhist year. Several early hanging scroll
paintings of this moment survive. One dating
to AD 1086, from the Heian era, contrasts the
stillness of the Buddha with the agitation of the
people and creatures all around him, including
a distressed lion. Scroll paintings of this subject
from the Kamakura period are in the British
Museum and in the Metropolitan and San
Francisco collections.

The iconography for this scene was
established early: the giant figure of the Buddha
lies down on a bed or dais among trees,
surrounded by grieving followers, birds and
animals. This 17th-century painter has
introduced a number of agitated caricature
figures and has set the scene by the sea.

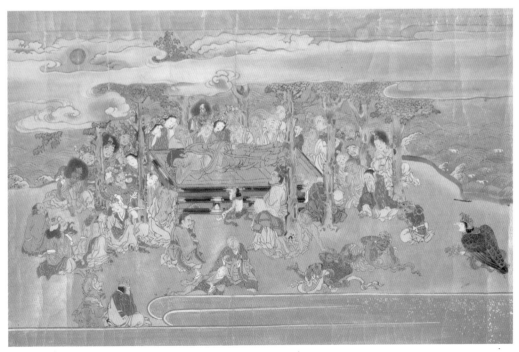

The Tea Ceremony

The Tea Ceremony developed as a way of focusing the mind and the spirit in the context of Zen Buddhism, although its roots are partly Daoist. From Chinese beginnings grew something uniquely Japanese. It includes the symbolism of yin and yang as well as the five elements, which are all present in the heating of water, making and taking of tea. Tea drinking became an elite activity, and the invitation to take part was an honour, especially if it was to the shogun's golden teahouse where the emperor himself was entertained. This was a political device, and the 16th-century shogun Hideyoshi also used tea masters as diplomats and go-betweens. He was introducing a new taste, including tea pavilions and Chinese-style ink painting, that was clearly distinct from the taste of the emperor and the court: Edo rather than Kyoto.

Normally tea pavilions were not golden but were instead much humbler, the opposite of the ostentatious display and delight in the rich and lavish known as kazari.

The essence of the Tea Ceremony combines harmony, respect, purity and tranquillity. The sense of harmony is created by the surroundings and choice of ceramics, flowers and hanging scroll, poetry and conversation. Colours, textures and filtered daylight can all be sensitively modulated. Respect is meant not just for each other but also for objects and sensations, of tea, nature and poetry. Purity is ensured by hand-washing and rinsing the mouth en route along the flagstones to the teahouse, an image of undecorated rural simplicity, where even the grandest visitor must clamber in through the narrow entrance and sit on a tatami mat. This reflects the Buddhist concept of wabi: simplicity, frugality and austere beauty. Raku pots are another expression of this simplicity and are considered more appropriate for the Tea Ceremony than the perfection of porcelains.

The tranquillity of the Tea Ceremony has been especially valued at times of war and disruption, and also of personal turmoil. The total experience can create a sense of ideal order through its rituals, which may seem a highly artificial process to those unfamiliar with it.

Although Buddhism teaches non-attachment to material things, the Tea Ceremony, like calligraphy and the Zen garden, employs carefully selected objects, textures and tastes to transcend the banal and focus on essentials as a means to greater serenity and sharpened awareness. Concentrating the attention in this way can help people focus on the beauties of nature, even when these are framed by neon lights and urban sprawl – as they so often are in modern Japanese cities.

Takahashi Dohachi II, Raku-style teabowl. Edo, 19th century.

Dohachi, who also carved netsuke, has decorated this bowl with a design of Mt Fuji that glows against the dark body of the pot. Raku can mean comfort, enjoyment or happiness and was awarded as a title to the potter Tanaka Chōjirō (1516–92) by the shogun Hideyoshi. Raku XV succeeded to the title in 1980. His work is greatly admired, and very expensive.

Raku is hand-built rather than thrown, with ground-up flint and sand often mixed in with the clay and a high lead content in the glaze. Raku is fired at a much lower temperature than either porcelain or stoneware. What comes out of the raku kiln is unpredictable and imperfections are admired –acknowledging the balance between the power of nature and human control over it.

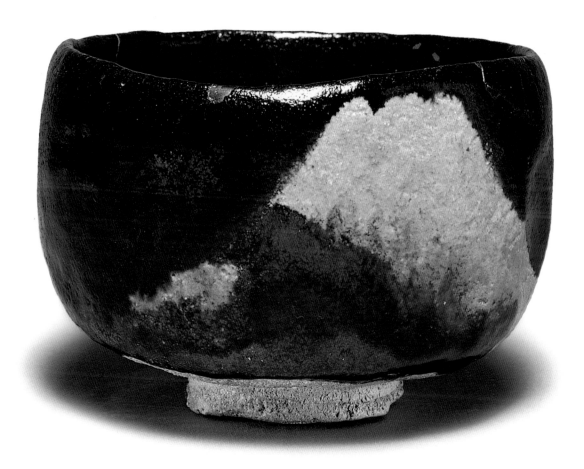

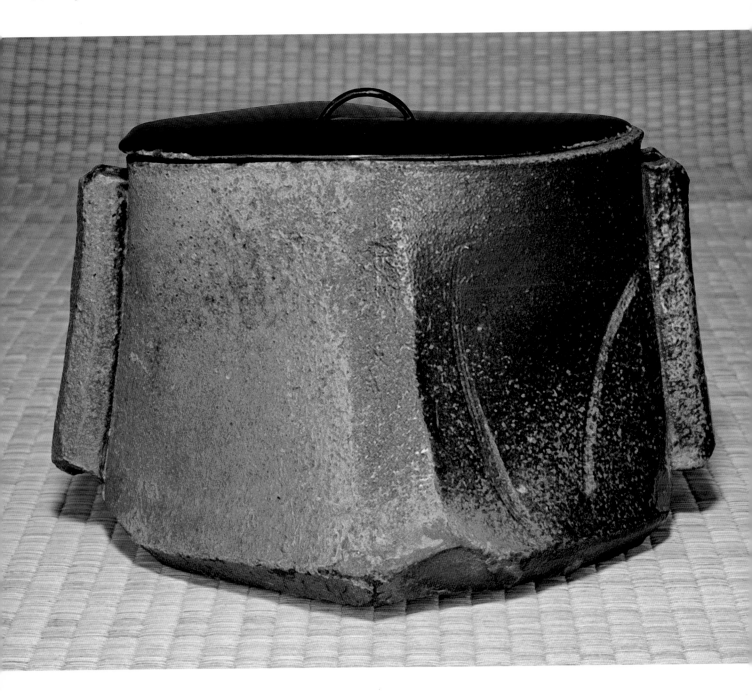

**Ceramic water jar (mizusashi), high-fired
with ash glaze, and lacquered wooden lid.
Edo, 17th century.**

In the Tea Ceremony, powdered green tea and
hot water combine to produce a thin broth
which is then whisked, its colours contrasting
with the sombre hues of ceramics like this jar.
Looking naturally rock-like, this jar was carried
to the teahouse with cold water, which was
then ladled (hence the wide mouth at the top)
into a metal kettle. This jar comes from Bizen,
one of Japan's most noted and long-established
ceramic-producing areas. The potter has made
slashes in the body of the jar. It could also be
hung by ropes through the cylindrical tubes at
each end.

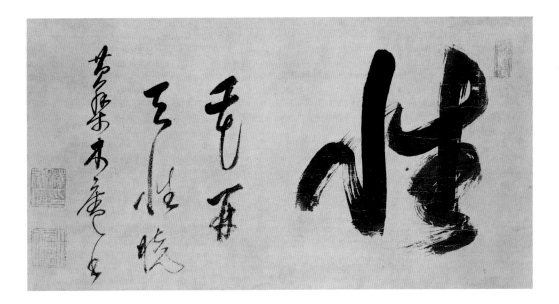

**Mokuan Shoto, Essence, calligraphic hanging
scroll. Edo, mid-17th century.**

Calligraphy is one of the most highly regarded art
forms in Japan. This was made by the abbot of a
Zen temple. The larger right-hand calligraphy reads
'essence'. At the left-hand side the long line reads:
'Flowers open and heaven reveals its essence'.
It perfectly expresses the core of Zen thinking.
Another Zen calligraphy by an abbot, 'Like Moving
Clouds and Running Water', is also in the BM.

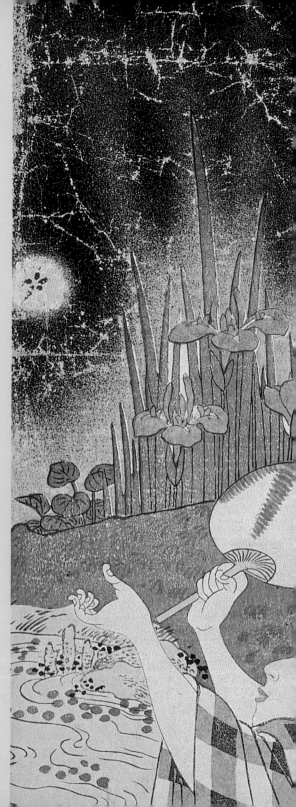

3 Nature

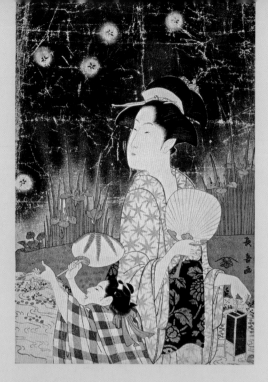

Shintō, Japan's indigenous religion, sees the sacred in nature, in animals such as deer, in plants, stones and waterfalls, and in landscapes, especially mountains. Here live the kami, divine spirits, for example in sacred Mount Fuji. This reverence goes back to prehistory, but so does the need to live off nature and the attempt to tame the natural world in all its turbulence. In Japan a wider symbolic vocabulary from nature has developed over the centuries than in China, which, along with Buddhism, has been the most significant outside influence on early Japanese art. For example, cranes represent long life, as do pine, bamboo and plum ('the three gentlemen of winter'); monkeys and deer

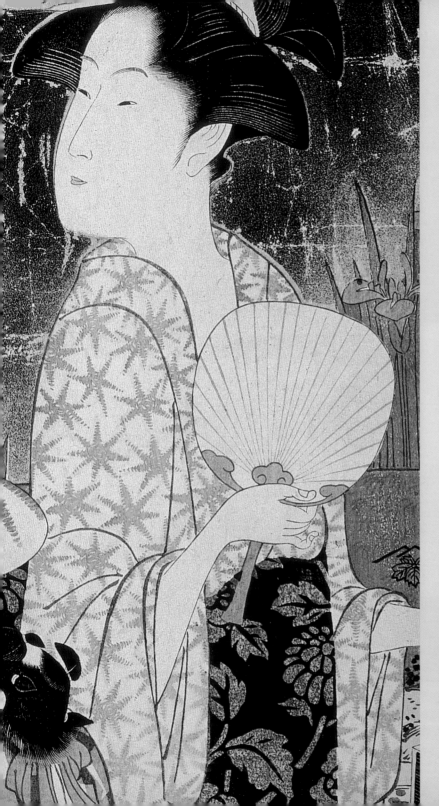

are messengers of the gods; dragons have several meanings. Foxes and racoons, on the other hand, might be evil spirits in disguise. So the most apparently straightforward of objects or paintings may hold many meanings and allude to poems, events and puns. For the artist the challenge is to convey the essence of the season or the creature, often imbued with a resonance from literature such as the medieval Tale of Genji. An appropriate hanging scroll depicting nature might be selected to accompany a reading of poetry during a Tea Ceremony at a particular time of year. Today a reverence for the benign aspects of nature is still part of many Japanese lives, as in the annual viewing of cherry blossoms, an opportunity for picnics. This moment lasts only a few days and is thus a favourite metaphor for passing joys in Japanese poetry: 'fleeting as cherry blossoms'.

Eishosai Choki (fl. late 18th century), Catching fireflies, colour woodblock print with powdered black mica ground. Edo, *c.* 1795. Beautifully expressive of a joy in nature, this print shows not only fireflies on a night in May but also irises, featured on famous screens and paintings, and the adaptation of flowers and leaves for textiles. It also reveals how even the typically mask-like face of an Edo beauty can appear alert and interested.

Lid of writing-box, black lacquer with gold and silver makie and takamakie.
Muromachi, 16th century.

This lacquer writing-box depicts a Shintō shrine and windswept trees by the sea. Here we are south-east of Kyoto, off the Ise Peninsula, close to the most sacred of Japanese shrines, and so near the two 'wedded rocks' which represent Japan's founding gods (at Futamigaura Bay). These rocks are linked anew each year with sacred ropes, and marked with a lone torii on the crest of the rock. A torii (literally 'bird-perch') painted red denotes the entry to a sanctuary, usually a Shintō temple. Cinnabar red is regarded as a magical colour to ward off evil and was found in prehistoric tombs, and also on the exteriors of medieval temples and palaces. Boats might have torii as well (see Hokusai's Great Wave, p. 97).

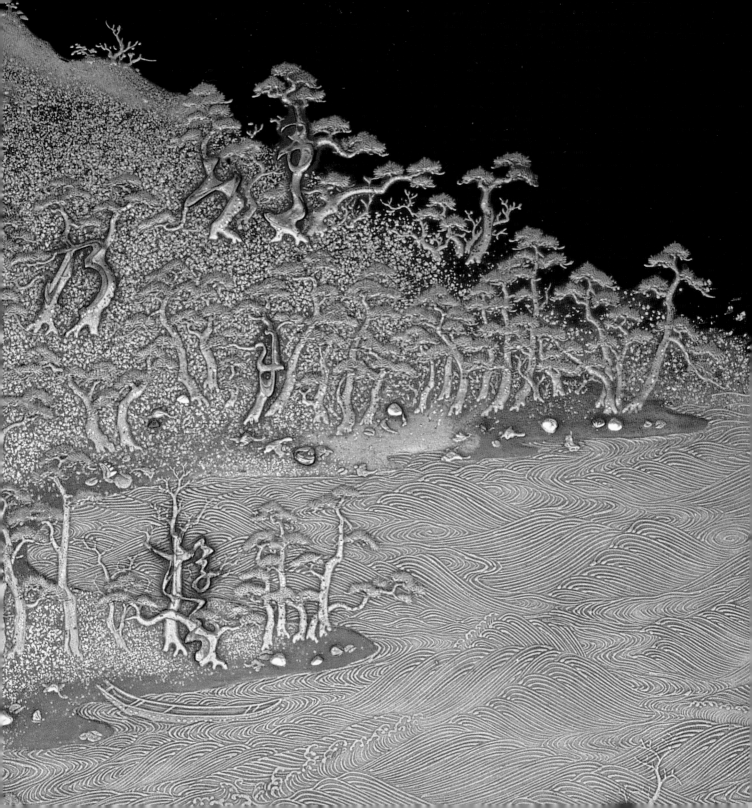

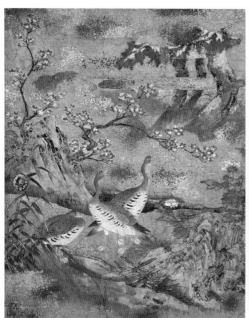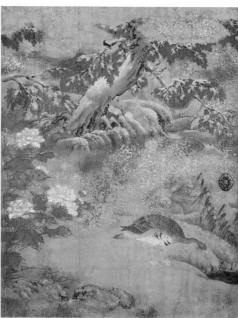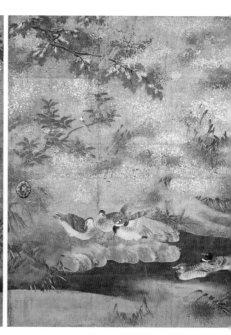

The passing of the seasons is one of the most common themes in Japanese poetry:

> Spring soon ends –
> Birds will weep while in
> The eyes of fish are tears

<div align="right">Matsuo Bashō (1644–94), at Senju</div>

Nature through the seasons might be captured in panel paintings for sliding doors (fusuma) in the uncluttered interior of a house or, as here, for a shrine. The sliding back and forth of the paper-covered doors, so familiar from films such as 'Kagemusha' and 'Ran', redefines the boundaries between enclosed and outside

Birds and flowers of autumn and winter, paintings for sliding doors. From Tanzan shrine, near Nara. Edo, early 17th century.

spaces, which relate so naturally in the most refined of Japanese buildings. This continuity of space from inside to outside, from depicting nature to viewing it, from the artificial and domestic to the apparently natural, has influenced many Western architects and designers as well as modern Japanese architects. For example, in his designs for the new Museum of Modern Art in New York and for other Japanese museums, architect Yoshio Taniguchi intends that the architecture should almost disappear.

These paintings are by the Kanō School, a dynasty of painters from the early Edo period who worked initially in Kyoto temples and palaces, whose work appealed to the warrior class of samurai. Panels like these might be juxtaposed with Chinese-style ink paintings and other Chinese treasures such as celadon porcelains and bronzes as a mood-setting context for conversation and poetry, creating a special ambience in the spirit of kazari, a delight in decoration.

Spring and summer are traditionally associated with the male and the sun, and autumn and winter with the female and the moon. Here we are moving from autumn into winter: the grasses and leaves are still green but the maples are turning red. Plovers, ducks and geese come down to the water's edge to drink or swim. Snow begins to appear on the cypresses and in late winter there are early camellias.

The composition is lyrical and dreamlike. Its main thrust, as so often with birds in flight or crowds of people (see p. 76), is a diagonal, leading the eye not only across the created space of the painting but out of it. We are looking not at one view but at several, made even more shimmering and unreal by the gentle drizzle of gold leaf, as if showered generously from the artist's hand.

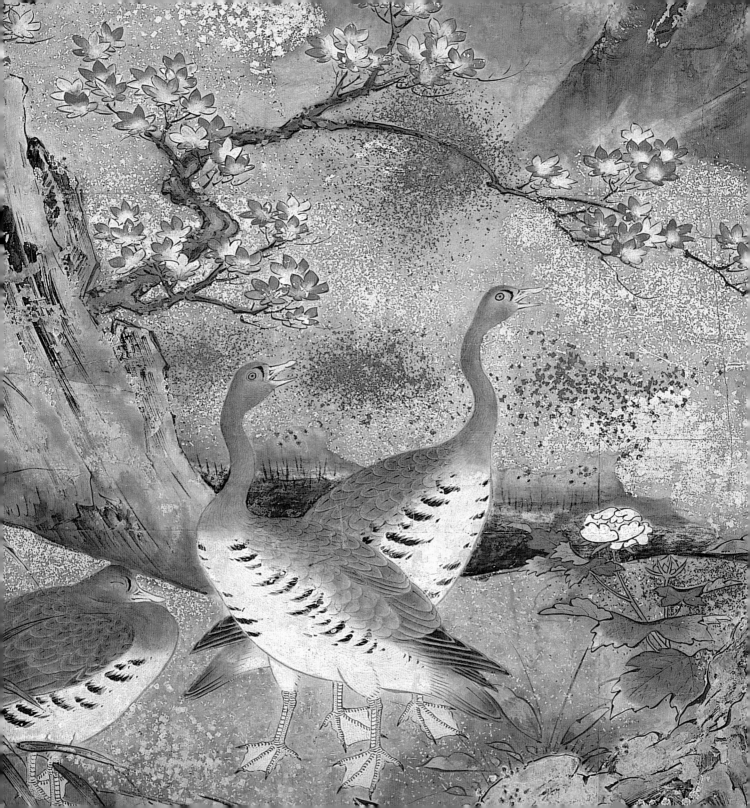

Nature is idealized
and dreamlike in these
paintings. There is
enough detail for the
eye to rest upon,
but not so much
as to distract from the
overall effect of
shimmering tranquillity.

Maruyama Ōkyo (1733–95), Cracked ice, 2-fold screen painting. Edo, late 18th century.

An illusion of cracked ice on a screen could conjure a cool feeling in a summer room, as in this screen painting by Maruyama Ōkyo. He uses a startlingly modern technique, leaving the spaces blank and defining snow or ice by a hard edge of ink. This low screen is designed to stand on the floor as an enclosure for a Tea Ceremony. The illusion when sitting in front of it is of ice actually on the floor. Ghost stories in films and plays also traditionally fulfil a similar role in the humid summer months for people in need of some chilliness (see chapter 7).

Ōkyo uses Western perspective, which Japanese artists discovered from Dutch and Chinese illustrated books in the 18th century, and in Ōkyo's case from designing for novelty viewing machines. He began from direct observation, from sketches of animals and people, rather than using

previous artworks as his model. In another two-fold screen for a Tea Ceremony he arranges seated figures on a blank background ('Nine Old Men of Mount Xiang', BM). His 'Sketchbook of Insects' shows direct drawing from nature, rather than from revered Chinese masters, and he is regarded as one of the leading realists in Japanese art. He was the founder of the Maruyama-Shijo School of painters in Kyoto,

who specialized in depicting nature in all its moods and colours. During Ōkyo's lifetime Kyoto was still the capital city (794–1868) and was still home to the largely ceremonial court of the emperor. Edo (modern Tokyo), seat of the shogun, the real ruler of Japan, was the commercial capital, with its own very distinctive culture.

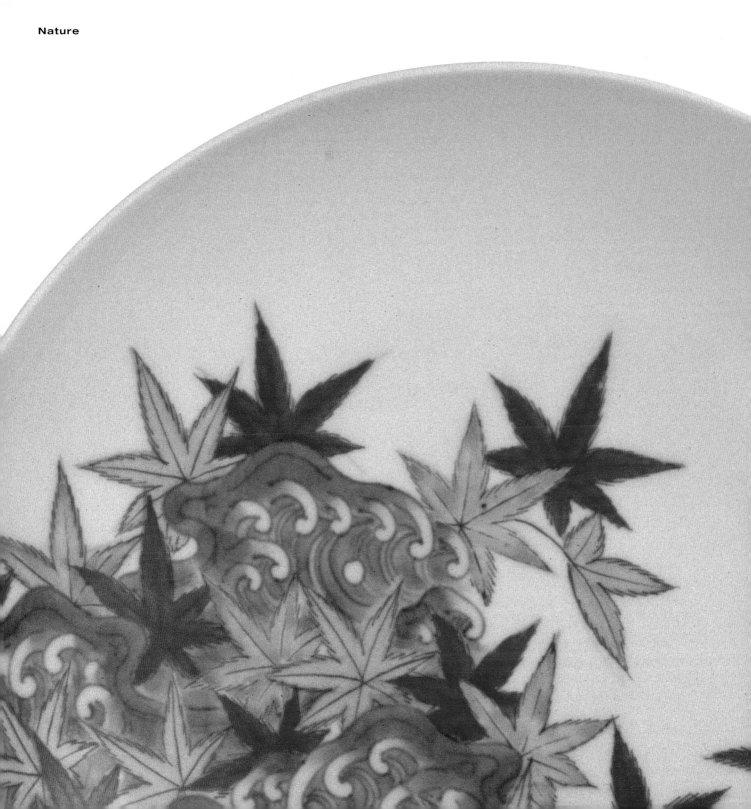

Nabeshima ware dish, with maple leaves over a rushing stream. Edo, 18th–19th century. Autumn colours also decorate kimonos, lacquer chests and porcelain. As in contemporary Europe, there was great demand in Edo-period Japan for more refined porcelain as decoration and also for eating. From the late 16th century, Arita was the porcelain centre of Japan, using techniques learnt from the Koreans who in turn had learned from the Chinese. Factories in the area produced wares for export via the Dutch, while smaller kilns worked for local lords. The results are stylishly Japanese with a distinctive use of pattern, as in the sumptuous textiles of the period.

This is an example of Nabeshima ware, named after a feudal clan. A three-dimensional sense of movement is created by using the curve of the dish to suggest a pool, and this also animates the rush of water behind the falling maple leaves.

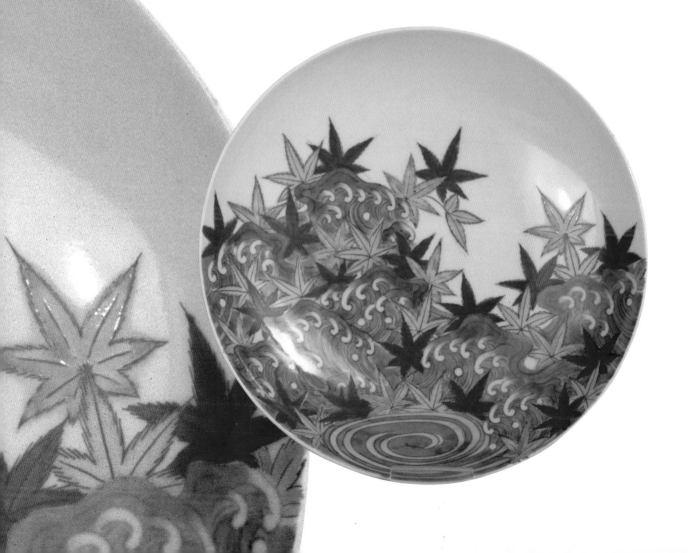

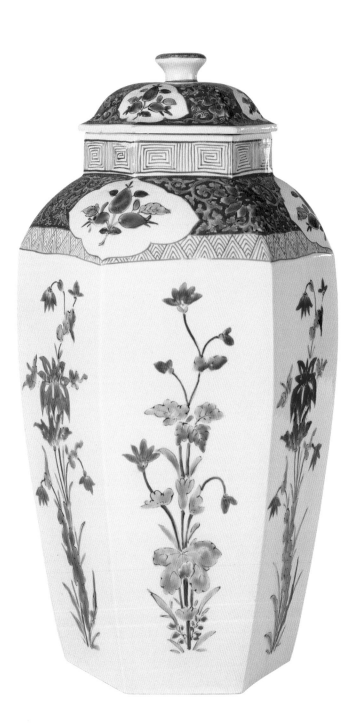

Kakiemon ware, lidded jar. Edo, late 17th century.

This type of porcelain was made from the early 17th century, also in the Arita area. It is named after the distinctive orange-red coloured enamel reminiscent of persimmons (kaki in Japanese), so the head of the family making these wares changed his name to Kakiemon. Today his descendant, Kakiemon XIV, is still in business in Saga prefecture. In the 17th and 18th century, Europeans enthusiastically collected lidded jars like this to stand on the floors or shelves of palaces and houses such as Hampton Court, Het Loo and Burghley House. Noted collectors included Augustus of Saxony and the Dutch (and English) Queen Mary, wife of William of Orange.

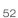

Black lacquer chest, with gold makie, gold and silver foil and mother-of-pearl inlay. Edo, early to mid-18th century.

Autumn grasses and deer appear on the front right-hand panel of this lacquer chest, made for export in the 18th century. The other panel illustrates a Chinese story in which an exiled courtier writes on chrysanthemum leaves. The use of lacquer – the resinous sap of the lacquer tree – began in prehistory as a way of waterproofing wooden objects such as bowls and protecting fragile objects like combs. Lacquer can be coloured red or black, and by applying many layers it is possible to cut through them to create sculptural effects. It became a form of conspicuous consumption for courtiers and the wealthy, partly because it is so labour intensive. For such patrons it could also be gilded with both gold foil and gold dust (makie, 'sprinkled pictures') and mother-of-pearl. A lacquer-like finish is still often a feature of modern Japanese design.

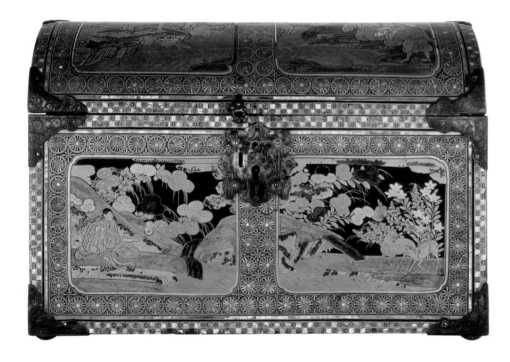

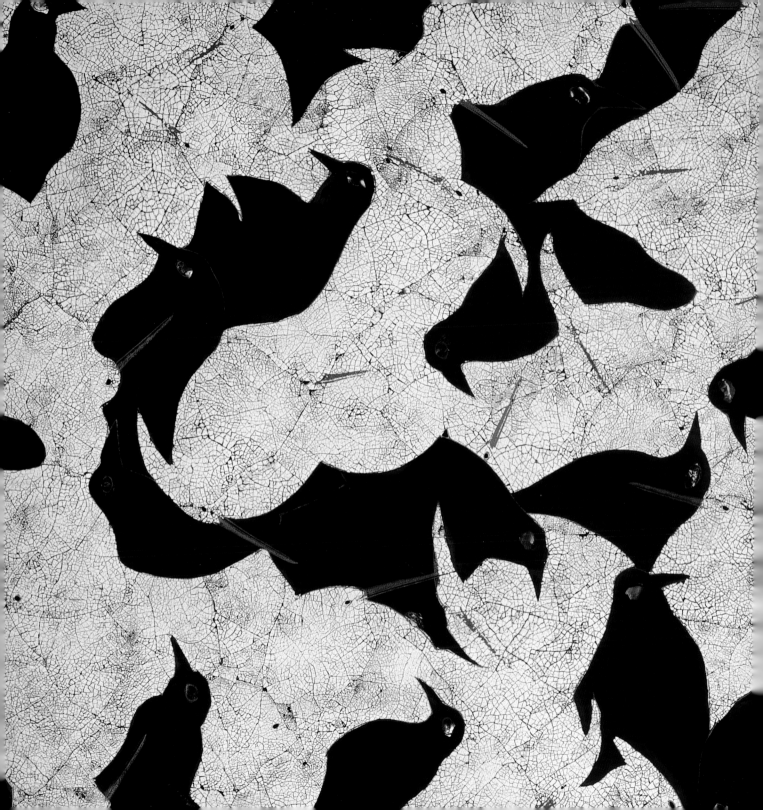

**Document box, black lacquer
with crushed eggshell. Edo, 19th century.**
This may look like something by the Dutch artist
Escher, but it is actually an extraordinary piece
of Edo lacquer. The design is of interlocked
black crows and white egrets, and the crows
have eyes of gold lacquer and mother-of-pearl.
It was designed to be admired as the owner
extracted papers from it, and he would probably
have also used an equally impressive lacquer
writing-box (see p. 64).

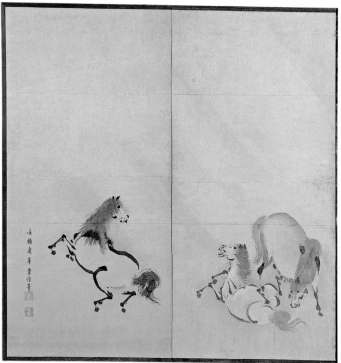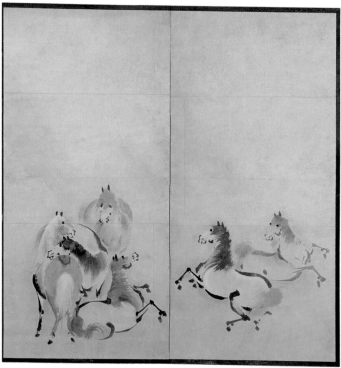

Mori Shūhō (1738–1823), Horses, 4-fold screen painting. Edo, late 18th century.

The space in this painting is entirely created by the movement of the horses – there is no ground or sky. This is a popular subject in Chinese ink painting, conjured here with a lightness of touch and deft handling of the brushes to create a perfect rhythm.

> Frisking horses
> Also sniff at their legs
> Wild violets
>
> Haiku by Chiyo-ni (1703–75)

Animals offered a rich opportunity to display artists' skills, and one of the leading specialists was Mori Shūhō. Here, like Maruyama Ōkyo with his 'Cracked ice' screen (pp. 48–9), he is doing more with less. This screen hints at how he reinvigorated the Kanō style, popular with the merchants of Osaka where he lived. Osaka was and remains a noisy, vibrant city, described as the 'rice-bowl of Japan'. Yet this art is subtle and refined.

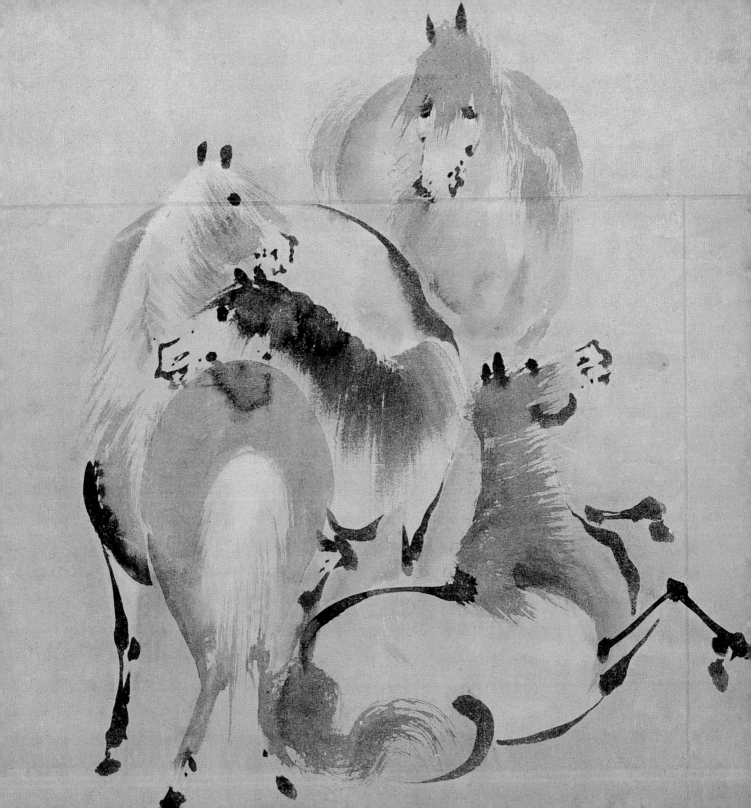

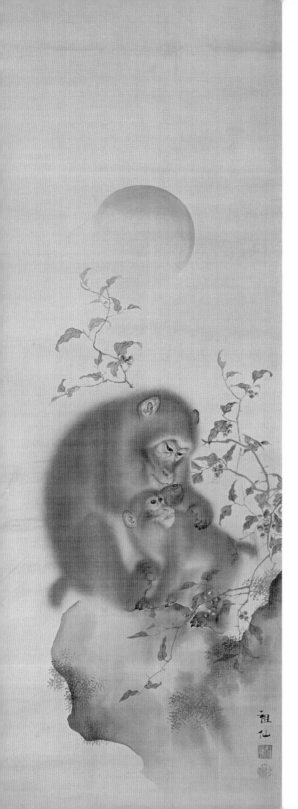

Mori Sōsen (?1747–1821), Monkeys, hanging scroll painting. Edo, c. 1800.

There is a Japanese saying that 'monkeys are only three hairs from being humans', and this is well captured here. The baby monkey watches as its mother inspects a blueberry from the bush, in an elegant and uncluttered composition. Monkeys, like deer, are regarded as messengers of the gods and appear in earlier Buddhist art with Kannon and cranes. Mori Sōsen (Mori Shūhō's younger brother) was so identified with the sensitive portrayal of monkeys that in his 60s he even changed the first character of his name to one meaning 'monkey'. An earlier noted monkey painter was Hasegawa Tōhaku (1539–1610).

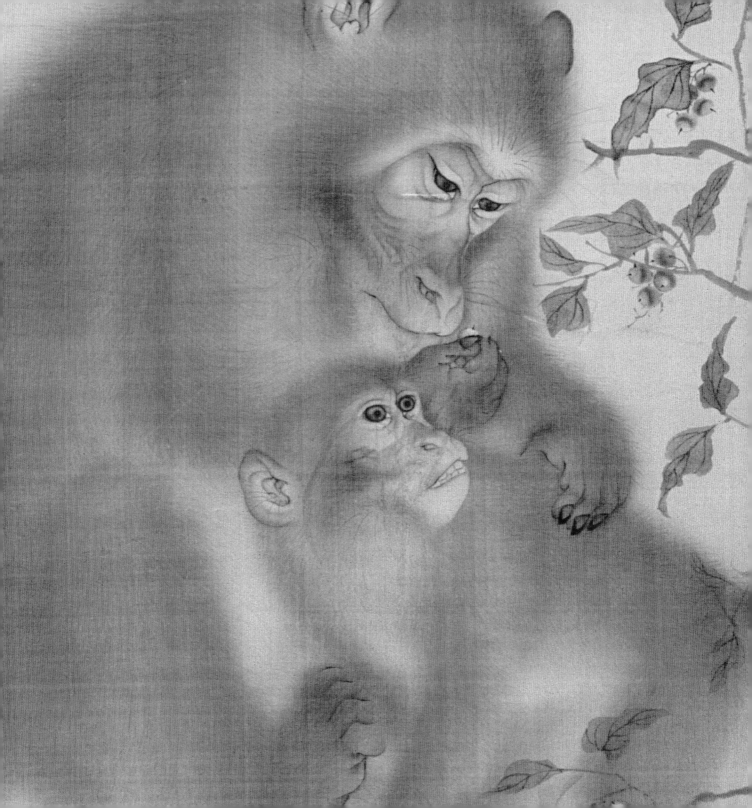

Kishi Ganku (1749–1838), Tiger,
hanging scroll painting. Edo, late 18th century.
Ganku hadn't seen a live tiger, but this didn't
prevent him from creating a vivid image of one,
presumably based on a tigerskin. Seen from this
angle, it doesn't matter that he hasn't seen a real
tiger move – we don't see most of the body.
The tiger is sharply in focus but the background
is sketchily realized, heightening the sense of
movement and menace. The confined format
also helps to achieve this effect. Another
example, Maruyama Ōkyo's hanging scroll of a
tiger (BM), is only 150mm across, and gives the
impression that the tiger might erupt into the
room through half-open doors.

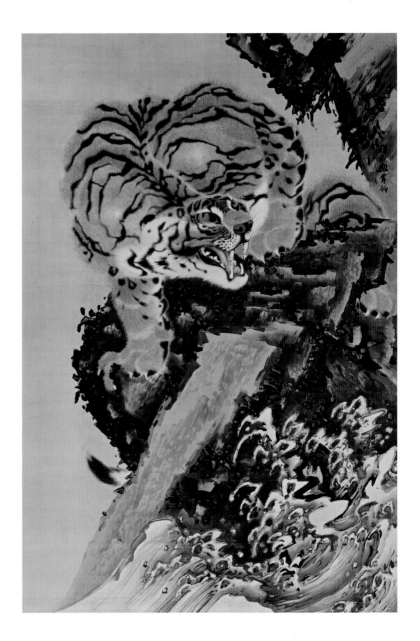

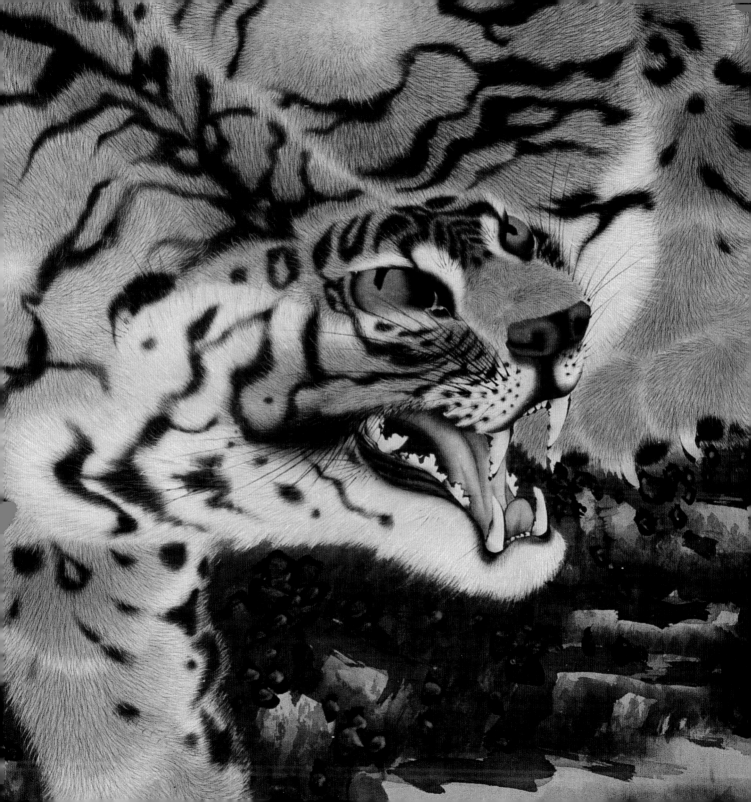

Writing-box, inside lid, black lacquer. Edo, 17th century.

This writing-box contains an inkstone for grinding a cake of solid ink. Water would be added from its small gilt-copper dropper, plus there would be brushes and knives. This exquisite vignette of deer crying in autumn is finely made using gold makie, shell and silver inlay, and copper foil, with mother-of-pearl to suggest depth and movement.

Deer were often regarded as sacred messengers of the gods and therefore a good omen. Deer still roam the parks around the Buddhist shrines at Nara, near Kyoto, where they have long been sacred to the Kasuga shrine.

Masanao, ivory netsuke of a rat, a kirin and a bird's claw. Edo, late 18th century.
Animals were also popular as netsuke, along with dragon kings, leering Dutchmen, masks, religious and mythical figures. Netsuke (literally 'root-fix' or 'attached to the end') were part of the solution to the problem of wearing a kimono. Because there are no pockets in a kimono or other robes, crucial objects (inrō-boxes for seals or medicines; pipe and tobacco pouch; writing set) must be hung on a cord from the sash of the kimono. They are then secured through a hole in a toggle of wood or ivory, or less often amber, coral or tortoise-shell. Originally a functional and undecorated toggle, netsuke became a form of customized ostentation for the new rich of 18th- and 19th-century Edo and Osaka, at a time when laws on ostentatious dressing were strict. The wearer needs to be able

to pull easily on them, so longish animals were popular subjects, and they are smooth so as not to catch on the clothing. Netsuke finally went out of fashion with the introduction of trousers after the Meiji Restoration, from the 1870s. They were soon attracting collectors worldwide, as they still do. These netsuke are by Masanao, one of the foremost 18th-century makers.

Rats are auspicious symbols in Japan, thought to bring good luck and wealth, so this netsuke may have been a gift for someone born in the year of the Rat. The kirin (familiar to modern beer-drinkers), also a symbol of good luck, is a distant relation of the mythical Chinese qilin. This one is reminiscent of a Greek centaur, half man, half creature. The bird's claw shows a scientific precision in observation, as also seen in illustrated books of the period.

4

Pleasure

Living only for the moment, turning our full attention to the pleasures of the moon, sun, the cherry blossoms and the maple leaves, singing songs, drinking wine, and diverting ourselves just in floating, floating, caring not a whit for the pauperism staring us in the face, refusing to be disheartened, like a gourd floating along with the river current: this is what we call the floating world, Ukiyo.

Asai Ryoi (d.1691), *Tales of the Floating World, c.* 1661

Mornings the floating world of Yoshiwara sleeps, weary, drugged by sake and other bought pleasures. Along the main street . . . flowering cherry trees scent the morning. The bright blossoms are already falling from the trees, trees that never bear fruit . . .

This chapter begins with traditional festivals in rural Japan, but mostly it is concerned with the pleasures of urban Japan, and the world of Ukiyo-e. In Edo-period Japan the gloomy Buddhist concept of 'Ukiyo' as a dark, shifting world of existence was transformed to mean 'floating', in the sense of pleasure. Ukiyo was a state of mind as well as a world of pleasure-seeking, as so often in Japan where a religious concept spills over into daily life. It promised release from the restraints imposed by samurai on the merchant class and urban life generally in a highly regulated society, where even the pleasure districts of Edo, Kyoto and Osaka were closely controlled.

Ukiyo-e are paintings and prints of one of the world's first modern metropolises. The roots can be found in the genre scenes on screens of the Momoyama period (late 16th–early 17th centuries). One pioneer was Hishikawa Moronobu, from the early 1670s. By 1700 Edo had a population of about a million, making it one of the largest cities in the world. This was the result of a transformation, in a

single century, from a swampy village in 1603 to a metropolis. The first Tokugawa shogun had forced the daimyō (feudal lords) from all over Japan to attend his court in Edo, swelling its population so that perhaps half were samurai and other attendants. It is not surprising there was such tension between classes in this caste society, and the need for somewhere to let off steam. These feudal lords were also encouraged very firmly by the shogun to spend their riches in Edo, rather than on developing their own power bases regionally. Artists, and luxury trades such as lacquer and textiles, as well as theatres and brothels, all benefited from the knock-on effects of this concentration of spending power.

The most celebrated pleasure district was that of Edo, the New Yoshiwara. This was outside the city, where it had been moved and then rebuilt after a fire, hence 'new.' It was built on a swampy reed moor, which is literally what Yoshiwara means, though its name could also sound like 'joyful moor'. The Yoshiwara was like a little town, surrounded by a moat laid out on a grid with walls and gates. This was a world separate from daily life and the demands of the city. Wealth and know-how mattered more than status in a normally very status-conscious society. No women were allowed in unless they worked there, as 6,000 women did at its zenith. These women were graded from courtesans, not usually on view in the windows, down to the cheapest of 'boat tarts' and 'night hawks', and listed in a directory, usually with prices. At their most glamorous they set the fashions and were celebrated, but only for a time. Ten-year contracts reflected the limited career of a fresh beauty. Harsh penalties policed the behaviour of both women and men in the Yoshiwara. Rituals had to be observed, and abortions and disease were common. Male artists are depicting an extremely male world, with and for a male gaze. We never see it from the point of view of the wives left behind at home, or the sex-workers, their child attendants and apprentices. Everyone is on show and performing, as if on a large stage. The second half of this chapter looks also at the theatre and briefly at sumō.

An Edo courtesan (see p. 78).

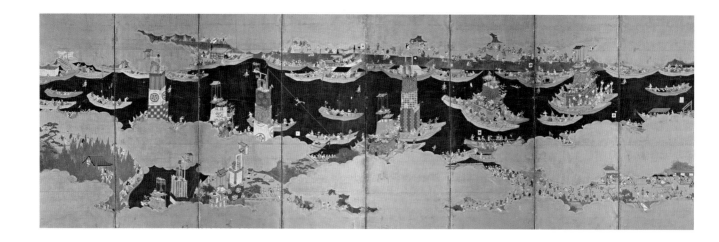

**The river festival at Tsushima shrine, pair of
8-fold screen paintings. Edo, mid 17th century.**
The Tōkaidō was the road linking the old capital
Kyoto with Edo, the new capital in all but name.
It was the subject of sets of prints by Hiroshige,
among others. Tsushima lies on the Tōkaidō near
Nagoya and was a major centre for Shintō
worship. This remarkable screen, with 16 panels
in all, captures the exuberance and elaborate
ritual of the midsummer festival, which still occurs
over two days every July. The action starts the
night before as shown in the right hand screen.

This is a different kind of narrative from the
kind we are familiar with from post-Renaissance
Western art. David Hockney has commented on
this type of Asian art, without a single fixed
vantage point, looking at a 17th-century Chinese
river journey depicted in a 20-metre-long scroll
painting (Day on the Grand Canal with the

Emperor of China). Here the viewer is like a bird
flitting around in the space of the riverside over
two days. We peek through the clouds, and our
eyes are gently led through the festival, but we
are not distracted by any single detail. The use
of gold clouds and mists as a framing device
goes back to much earlier Japanese art.

This screen is itself an especially lavish
example of kazari (display), as is also what it
depicts: the use of sumptuous textiles and
shows, for example, to please both the kami
(spirits of the shrine and the river) and the
audience at the festival. Their delight is evident.
A grand festival like this is an example of 'bread
and circuses' staged by a branch of the ruling
Tokugawa shogunate. By extension this screen
also reflects on the powerful connections of its
owner, and his wealth in possessing such a large
and lavish artwork.

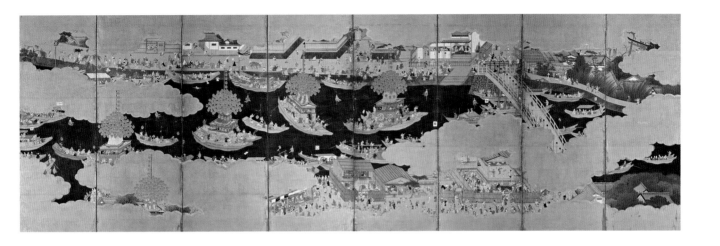

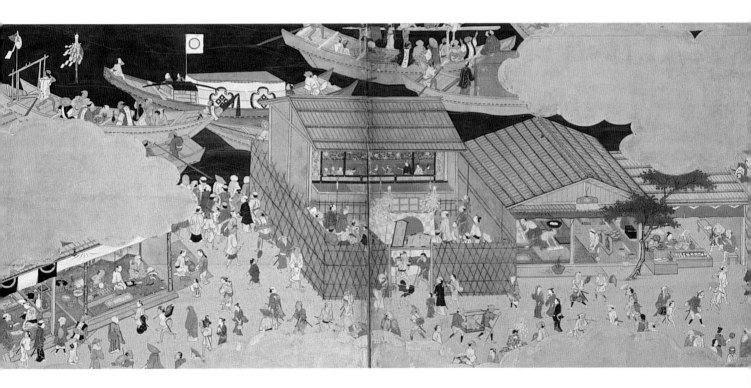

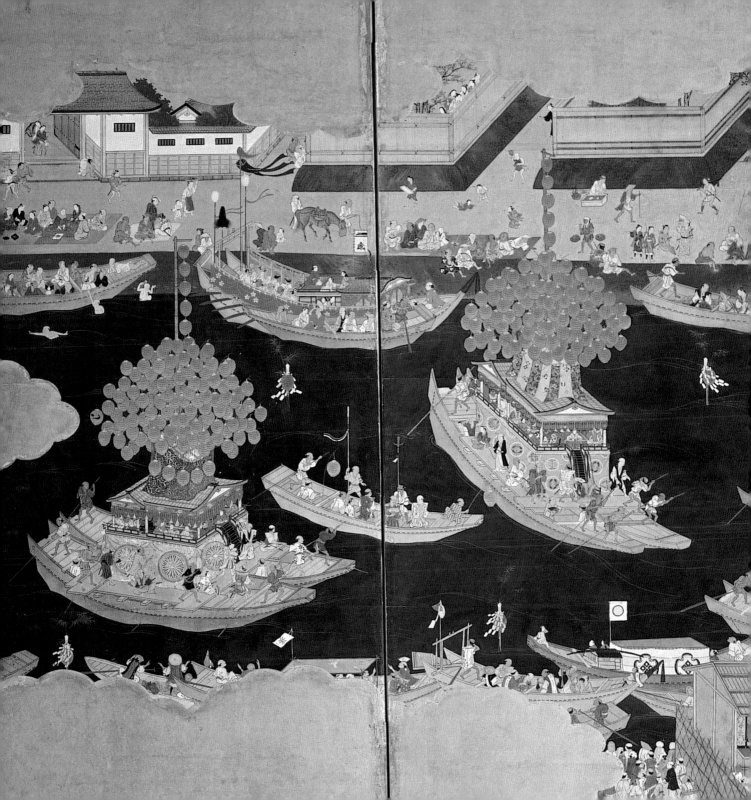

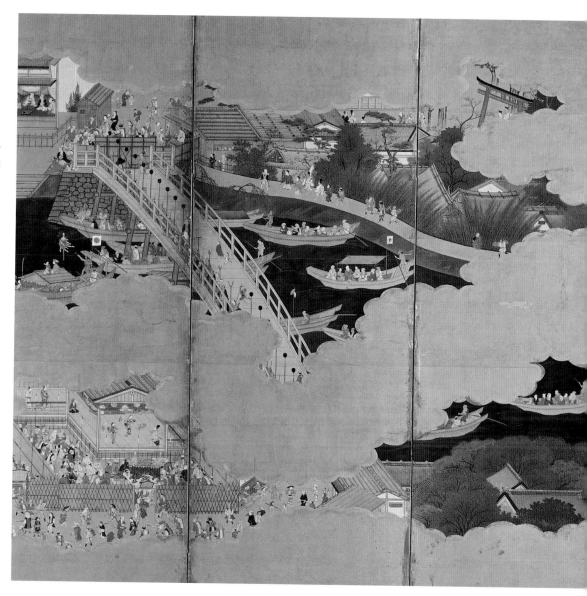

Lanterns were (and still are) a local speciality. Here they look like giant bunches of flowers as they are being punted along at night, to magical effect.

Here we can glimpse the Tenno bridge and a distant view of the torii (ceremonial gate) of the shrine, at the extreme right of the right-hand screen.

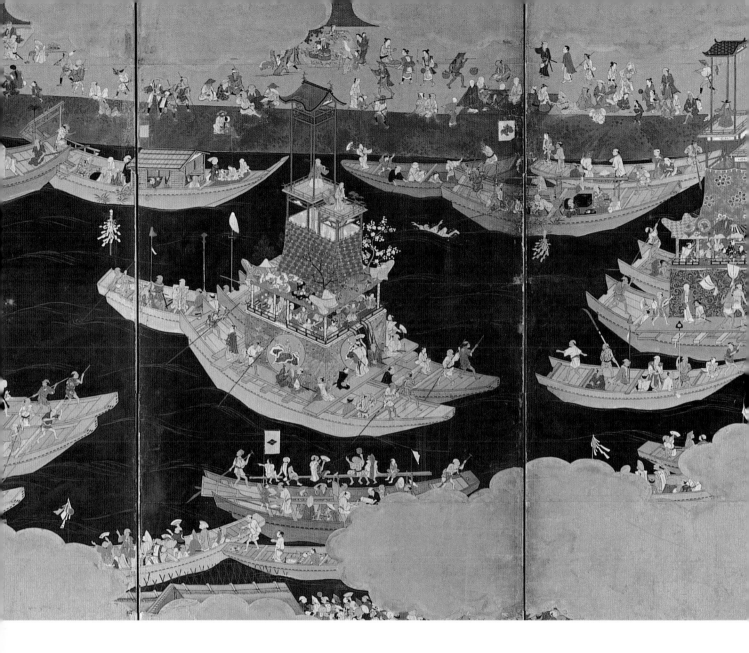

The following day the lanterns are replaced by giant
towers on boats, some capped with dragon sculptures.
There are platforms for mechanical dolls to perform
famous Nō drama roles, with musicians hidden away.

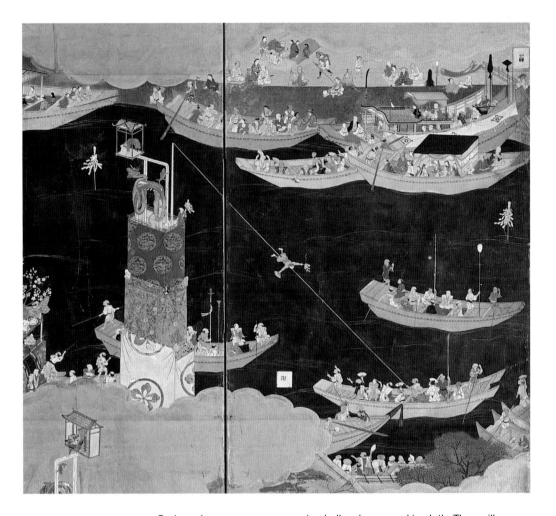

On board are young men carrying halberds covered in cloth. They will jump into the river, swim across and dedicate their weapons at the shrine. Along the riverbanks we can glimpse picnics, horses with nose-bags, shops and eating houses, improvised kabuki theatres, and a hair-raising tightrope acrobat. Anchoring all this activity at the extreme left (the end of the narrative) is another little building, surrounded by the freshest of green foliage (right).

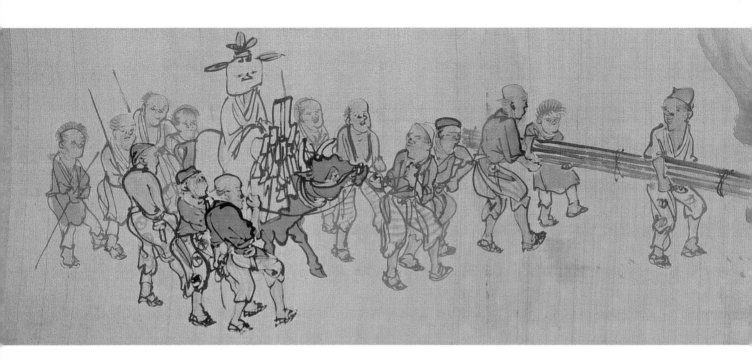

Kawamura Bumpō (1779–1821), Japanese festival scenes, pair of handscroll paintings. Edo, c. 1810.

Here we are at a different kind of festival, this time in Kyoto. At the autumn Ox Festival there are entertainers, sumō wrestlers, a monkey-trainer, street traders and happy crowds.

This detail shows a masked figure in white riding the ox and representing a Shintō deity.

He is preceded by four masked attendants and lantern- and torch-bearers.

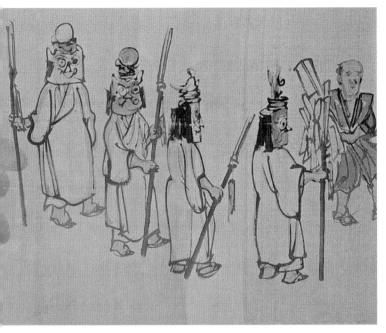

The artist, Kawamura Bumpō, has been described as an 'artist of two worlds'. In these scroll paintings he shows two kinds of culture and pleasure: Chinese-style literary as well as Japanese popular culture. In this detail a Chinese Immortal, after three cups of wine, 'writes on the paper like a fleeting cloud'. Bumpō studied under Ganku (artist of the tiger on p. 62) and shows a vigorous brush line, characterizing sages, grasses and lowlife alike.

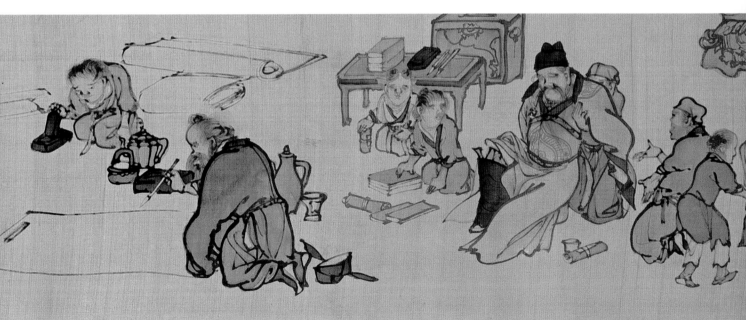

Saitō Shūho (1769–1859), Courtesans on parade, from 'Mr Aoi's Chronicle of Charm', colour woodblock printed book. Edo, 1803.
Here we visit Osaka which had a pleasure quarter like Edo, but an earthier one, catering almost entirely for the tastes of merchants. As one historian has observed, 'only in the brothel and theatre district could merchants rise to a social position that was equivalent to their wealth'. These clients of the courtesans were also the clients of artists like Bumpō. They wanted to see their own world reflected in art, just as the courtiers, samurai or devout Buddhists did.

This is the New Year display of new kimonos given by wealthy clients. The number and expense of a woman's new kimonos showed how popular and desirable she was. Such processions could be big events, with the staff of the pleasure houses joining in. This one is on its way to the temple of Aizen Myō-Ō, with maids and child attendants. Their umbrellas display the aptly phallic logo of their brothel – a mallet!

This is the opening page of a three-volume tribute to the vibrant life of Osaka, and appropriately it is New Year. The artist is here lively and crisp, though he later became a humdrum member of the Kanō School. The procession makes a strong diagonal across the page, read from the right like the book itself. See Toulouse-Lautrec, 'Le jockey' (BM), for an example of the impact of this idea on French artists.

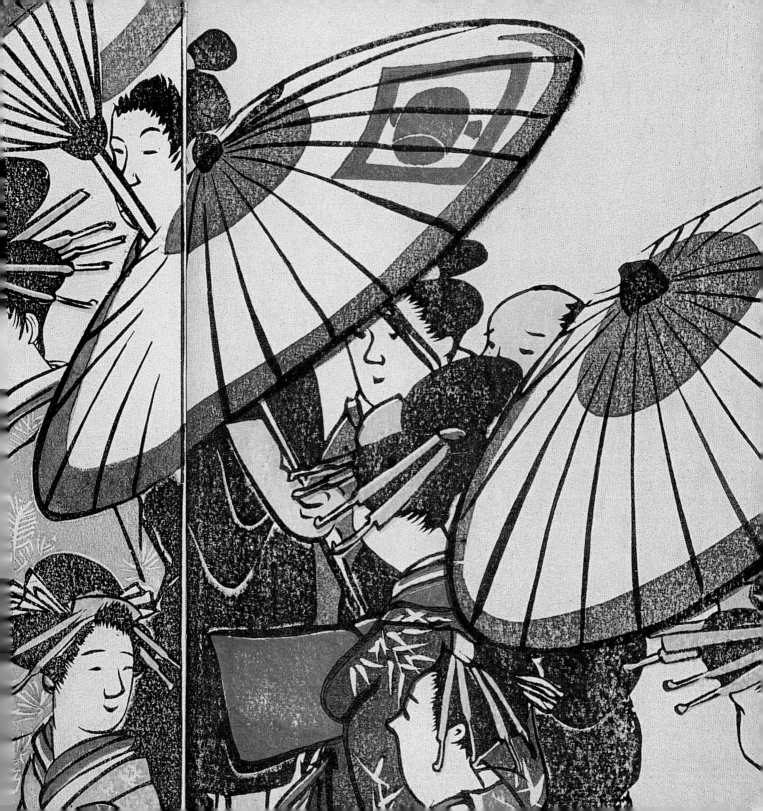

**Kitao Masanobu
(1761–1816),
The courtesans
Hinazuru and Chōzan,
colour woodblock
print. Edo, 1784.**

The Yoshiwara is like Paradise by day and like the
Dragon Palace at night . . . the rarest foods and
exotic fragrances . . . The pleasure quarter is a
place where you should throw away gold and silver.
If you don't want to waste money, why go there?

Kato Eibian (*My Robe*, 1820)

These courtesans aren't anonymous but named
celebrities, and examples of their actual
calligraphy are displayed behind them. The mood
is one of sophistication as expected of
courtesans (available sexually for a wealthy few)
and geisha (who entertain, but not sexually). As in

the Osaka procession (pp. 76–7), we see a
display of the new kimonos given at New Year
and can sense how heavy they are, as symbols of
a patron's interest. Also on show are three child
attendants and a teenage apprentice: trainees
began as young as five. The rich patron has also
supplied suitable décor and comforts – here we
can see an ornate Chinese-style writing desk,
black-lacquered and with mother-of-pearl inlays.
An exotic European beauty stares out from a
frame at bottom left. The new bed quilts pile up
on the right. The artist has created an image that
is lavish in content, printing and format.

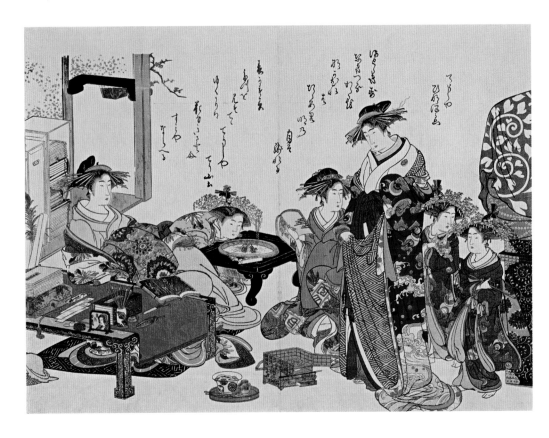

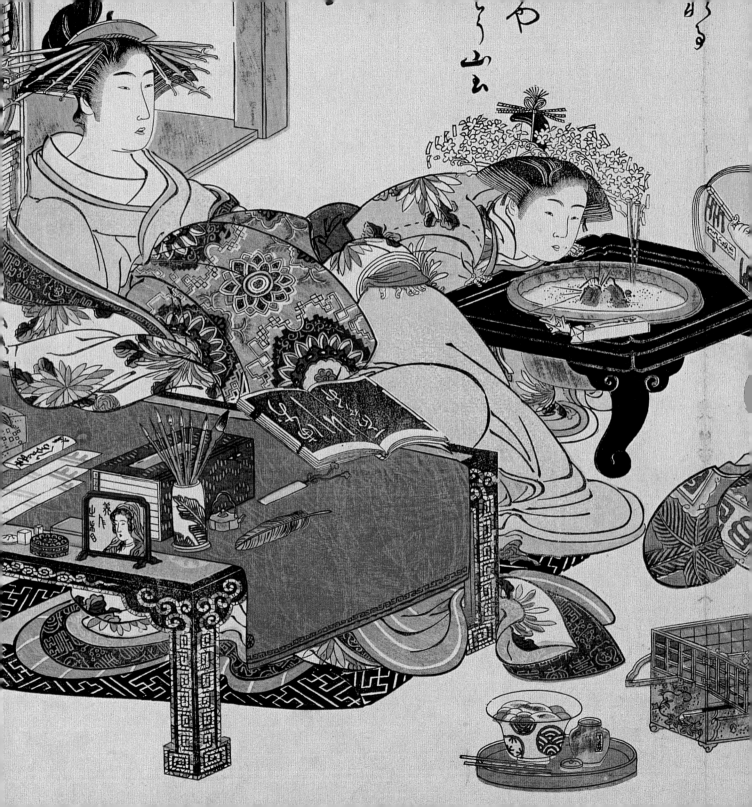

Kitagawa Utamaro (1753-1806), Lovers in an upper room, from the album 'Poem of the Pillow', colour woodblock print. Edo, 1788.
There are many scenes of brothels and tea houses in Ukiyo-e art, as well as an extremely lively tradition of explicit images (shunga) by artists like Kunisada and Eizan. No artist, however, is as lyrically erotic as Kitagawa Utamaro, who produced over 2,000 single-sheet designs for prints, ranging from natural history to the bedroom. Utamaro is the master of erotic understatement. We see no faces, just one of the man's eyes, nor any explicit activity as in most shunga. Eroticism is in the nape of the woman's neck, and in the merest suggestion of what might be happening or about to happen.

The poem on the fan says it all:

> Its beak caught firmly
> In the clam shell,
> The snipe cannot
> Fly away
> Of an autumn evening.

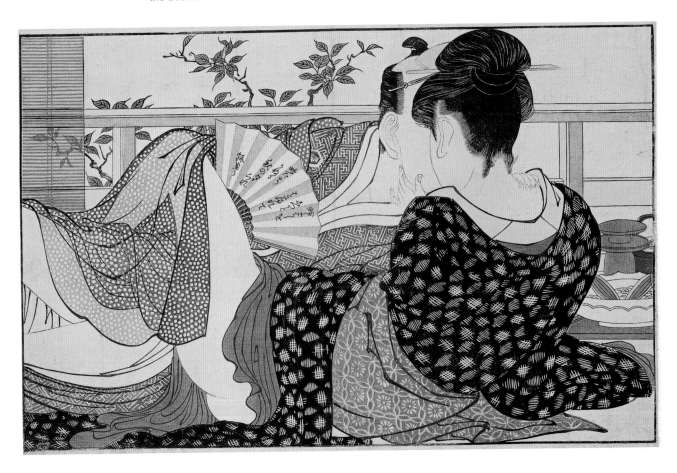

Theatre

**Nō mask of a young woman,
painted wood. Edo, 18th–19th century.**
Kabuki actors and beautiful women were the
most popular subject matter for Ukiyo-e
printmakers. An earlier tradition from medieval
Japan, Nō theatre, also survives today as the
ultra-refined courtly drama of understatement,
in sharp contrast to the much more boisterous
kabuki theatre of the cities. Nō drama, with its
hypnotic dancing to drums and flutes, greatly
impressed the English composer Benjamin
Britten, who translated its stylized ethos into
church parables performed by monks in a
church ('Curlew River' is based on the play
'Sumidagawa', which Britten saw in Tokyo in
1956). This mask shows medieval Heian ideals
of feminine beauty: eyebrows were shaved,
others often painted on at the top of the
forehead; teeth were blackened on coming of
age, with a ghastly brew of powdered iron filings
and gall nuts steeped in vinegar or tea. Because
masks were used, gestures are needed to
indicate emotions: a touch of the sleeve may
suggest happiness in love, and a raised right
hand can indicate weeping.

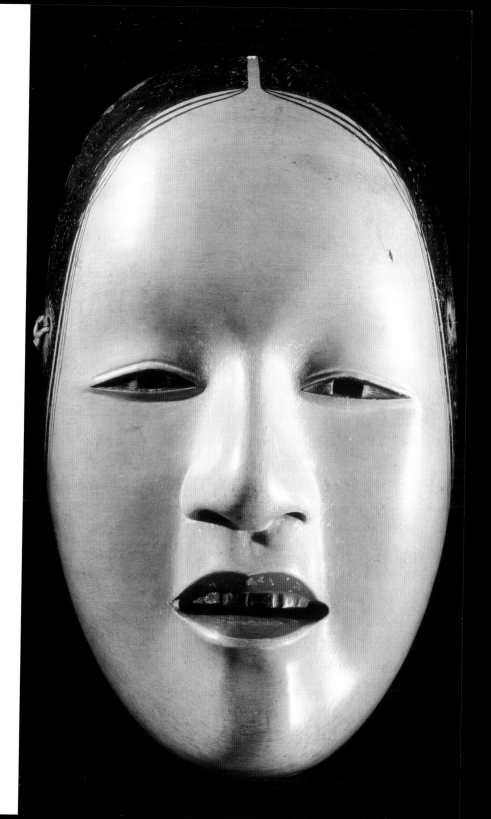

Kabuki theatre was notorious and stimulated the birth of a new art form. Kabuki (literally 'song, dance, skill') was the creation of the urban world of Kyoto, from which it reached Edo in the 1620s. There was also a very lively tradition of kabuki in Osaka. There has long been rivalry between these three major cities and their different cultures, and therefore different styles of kabuki, characterized as 'rough' in Edo, 'soft' in Kyoto. Inevitably, with its potential for satire and comment, kabuki was regulated by the state. The samurai government kept clipping its wings: female actors were banned in 1629, then the boys who took over the female roles were also banned in 1652. From then on it was entirely up to the men. Early founding fathers included Ichikawa Danjūrō (1660–1704), in honour of whose descendants Ichikawa Danjūrō V and VIII the Kunimasa and Kuniyoshi prints were commissioned (pp. 88–91). As late as 1842 further attempts were still being made to close kabuki down altogether.

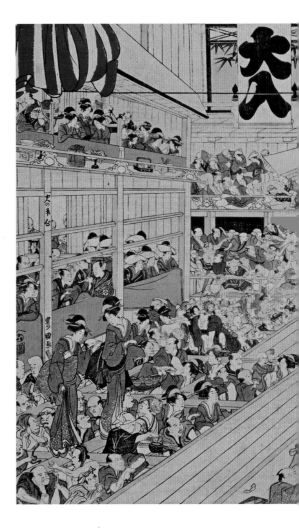

Utagawa Toyokuni I (1769–1825), Kabuki theatre, triptych of colour woodblock prints. Edo.
This print shows how close the audience is to the actors, and how directly they were involved, responding with cries of 'I was looking forward to that!' and the actors' names. Similar to Shakespearean theatres, there is a small timber house on the main stage, with a curtain pulled across before the performance begins.

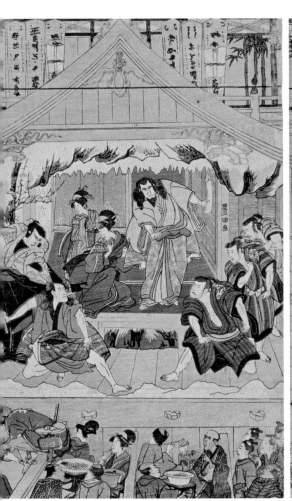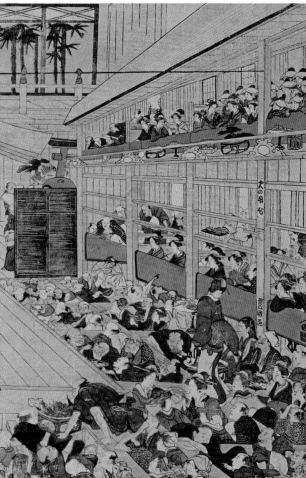

Often a large revolve stage and lifts enabled sudden changes and surprise entries; other quick changes might take place on stage to great applause. Stage effects included snowstorms. Running up the left-hand panel of this triptych is the hanamichi, the runway that enables a star actor to make a dramatic entrance through the audience, freezing his pose to a rapturous response.

Complete kabuki performances might last from dawn to dusk, telling very long stories. So inevitably a visit to the kabuki theatre also involved eating and drinking. Modern audiences may still drink tea in their boxes at Kyoto's kabuki festival and eat their lunch boxes during the interval, but performances are much shorter and usually comprise famous scenes from different plays. Audience interventions are also more controlled nowadays.

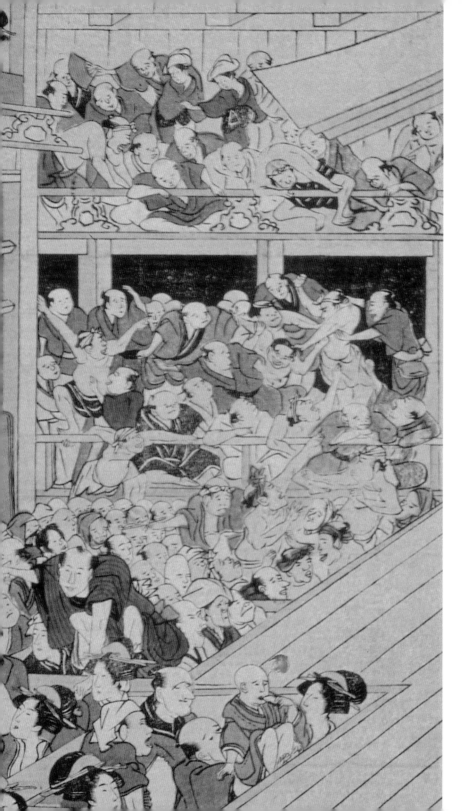

Many of the audience (left) appear not to be following the performance (right) at all, intent instead on eating, drinking or scuffling with their neighbours.

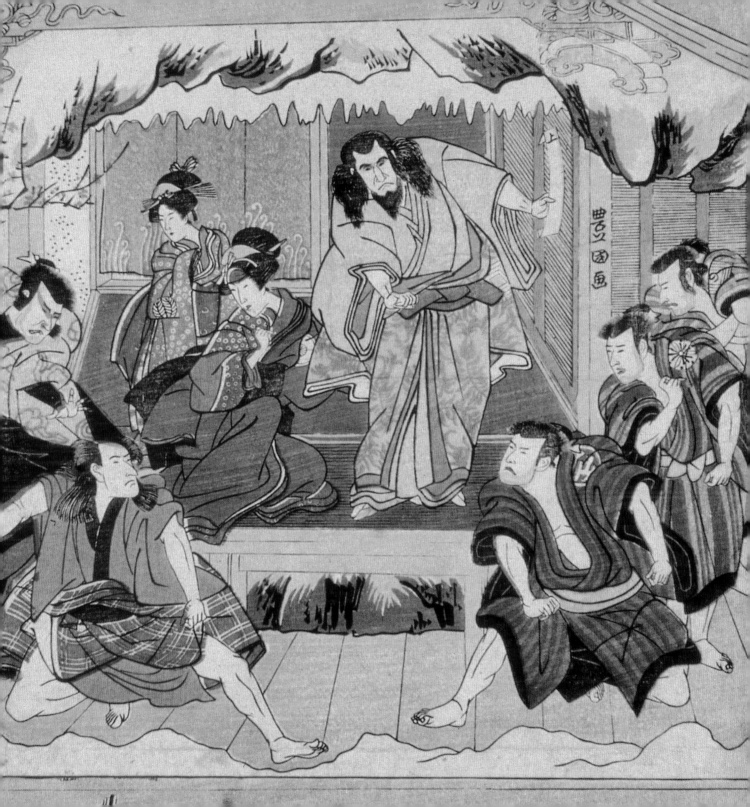

Then and now it was the actor that mattered rather than the play or the director, so actor prints are rather like a superior fanzine or pin-up – ephemeral, and therefore more likely sometimes to survive in a Western collection than in Japan. Actor prints were developed by the Katsukawa School founded by Shunsho, who trained Shunei and Hokusai. The greatest and most idiosyncratic master of the actor print was Tōshūsai Sharaku, about whom remarkably little is known. Sharaku produced about 145 actor prints in the ten months of his career as an artist. He may well have been a Nō actor himself, which might explain his insight into actors and acting. His publisher dropped him, and it has been suggested that this was because he depicted kabuki actors so sharply that they objected. Sharaku was not alone in depicting the grotesque: it can also be seen in paintings of the time by Rōsetsu, for example. Printmaker Utagawa Kunimasa also created brilliant (but more respectful) characterizations of actors.

Tōshūsai Sharaku (fl.1794–5), The actors Nakamura Wadaemon and Nakamura Konozō, colour woodblock print. Edo, 1794.

These are clearly two old pros. The character on the right is on his way to a house of pleasure in the Yoshiwara; the other is a ferryman, and they are haggling over the price.

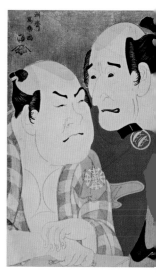

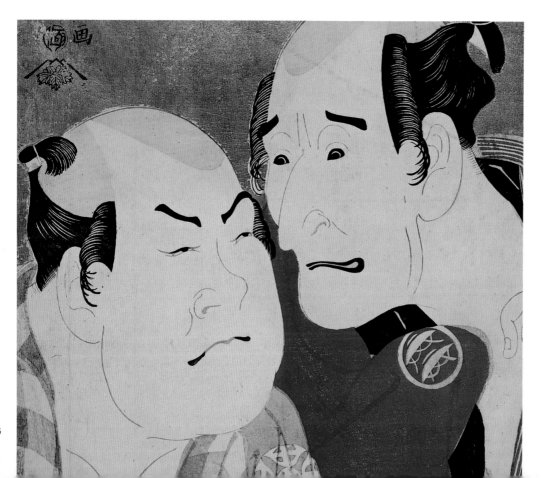

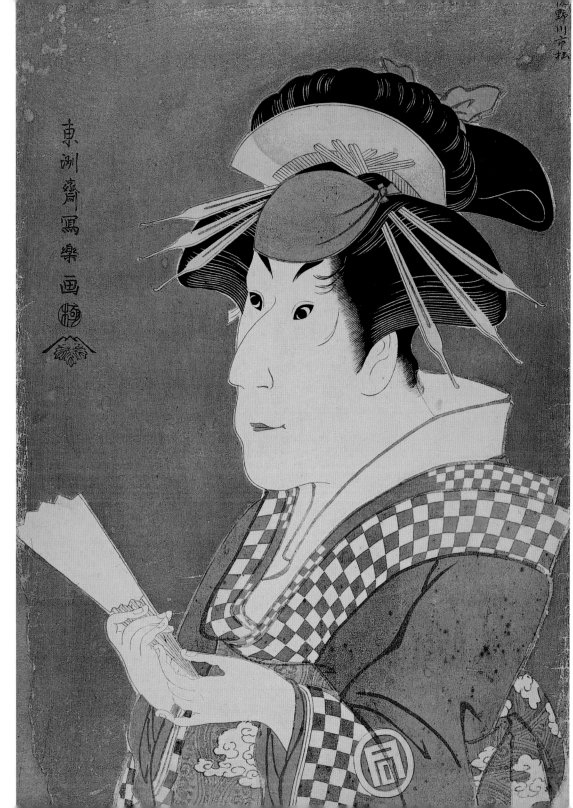

Tōshūsai Sharaku (fl.1794–5), The actor Sanogawa Ichimatsu III, colour woodblock print. Edo, 1794–5. Ichimatsu is playing a female onnagata role. Despite his mask-like makeup, it is clearly a man beneath it. There is a traditional high-pitched voice for this kind of role, along with stylized movements.

**Utagawa Kunimasa (1773–1810),
'Wait a moment!' The actor Ichikawa Ebizō
in a shibaraku role, colour woodblock print.
Edo, 1796.**

This famous print marked a great kabuki actor's retirement from the stage with a show-stopping moment from one of his most celebrated roles. At a crucial hiatus in the action he appears at the back of the theatre and shouts 'Shibaraku', 'Wait a moment!' and rushes down the hanamichi walkway, saving the day just in time. The three white lines on his costume are part of his family crest as aristocrats of the stage. His stylized red make-up is characteristic of the Edo 'roughstuff' for heroes (blue is evil).

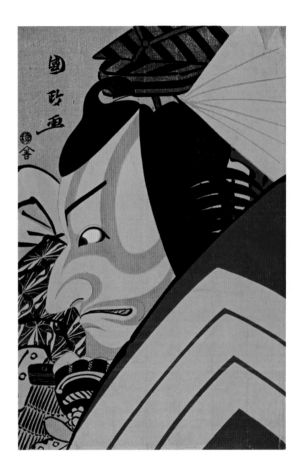

Utagawa Kuniyoshi (1797–1861), A farewell surimono for Ichikawa Danjūrō VIII, colour woodblock print, 1849.

The occasion for this print is two-fold: the departure of the celebrated kabuki actor Ichikawa Danjūrō VIII to visit his exiled father; and the Boys' Festival on the fifth day of the fifth month. Evil spirits are believed to be at their worst then, so any family with a boy under the age of seven would hang a paper or cloth carp banner from their roof. Carp, especially when swimming upstream, represent perseverance in Japanese art. This surimono was commissioned by a poetry club of fishmongers – the actor's logo was also a lobster. The actor's father is seen in a famous role as Shōki the demon-queller on one banner, pursuing the demon on the other banner which flutters to the left.

Other artists of the period who specialized in actor prints include Kunimasu (fl.1834–52) and Shunkosai Hokuei (d.1836), both of whom are well represented in the V&A collection. Later actor prints from the 1920s are by Shunsen Natori (1886–1960) and Kanpō Yoshikawa (1894–1979), and even in the era of colour photography the printmaker Kōkei (b.1946) still depicts kabuki actors.

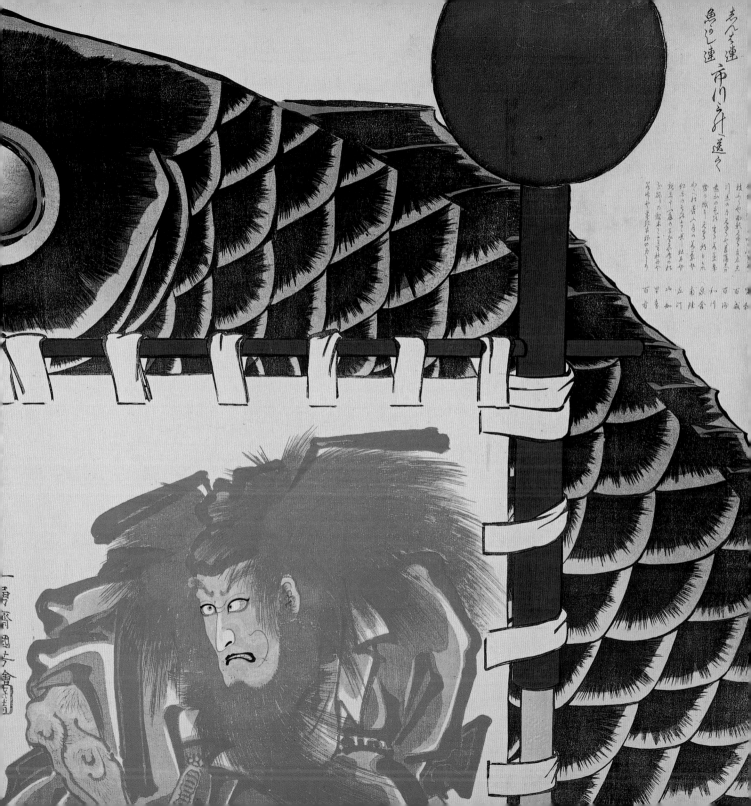

**Ay-o (b.1931), Sumō wrestling,
silkscreen print, 1984.**

Sumō wrestling is another spectator sport, here
captured in a vibrant modern print. Sumō
originated as part of the Shintō religion, perhaps
2,000 years ago. Sumō tournaments were held
at shrines as part of harvest thanksgivings, and
even today the referee is dressed as a Shintō
priest. Sumō became a professionalized
spectator sport during the Edo period and is
now watched by millions on TV, not just in Japan.

This is a striking silkscreen print by Ay-o,
the adopted name of a painter and printmaker
based in Tokyo and well-known internationally.
His work shows the fusion of modern Western
and older Japanese art. Ay-o was heavily
influenced by Pop Art when in the USA in the
1960s. He creates large acrylic paintings and
silkscreen prints in a rainbow of vibrant colours.
He exhibited at the Venice Biennale in 1966 and
has created a series of installations as a
member of the international Fluxus Group,
which includes artists such as the Korean Paik
Nam-June (b.1932).

The two outsize bodies are squeezed into the
space, giving it energy and drama. By reducing
virtually all detail to outline, the artist is able to
focus our attention on the tensed toes and leg
muscles, the wrestlers' arms grasping and
attempting to push each other over, and the
fringe and giant bow of their belts. This image
is based on a woodblock print by Utagawa
Kunisada (1786–1864) (see pp. 12, 114), and as
a tribute his signature is included in the bottom
right-hand corner.

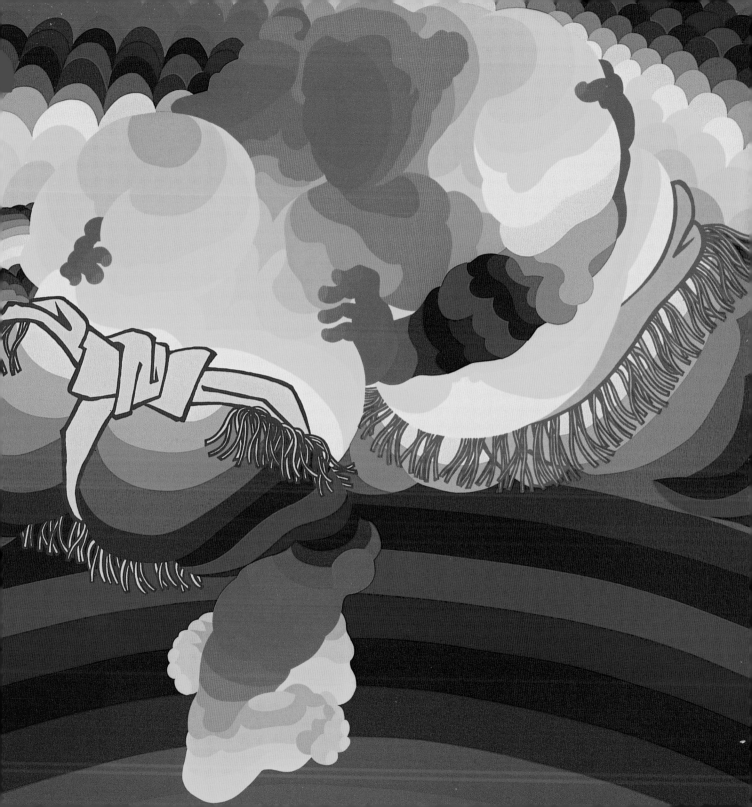

5
Mountains and sea

Most of the interior of Japan is mountainous, leaving its people perched between mountains and sea, and never far from either. Japanese landscape art therefore resonates between the two. There is a feeling of looking outwards and inwards at the same time, and of measuring mankind against the elements. These may be tamed symbolically, as in a Zen garden that expresses awe for nature, a framework for contemplating it and a desire to control it, with a few carefully selected and positioned rocks in a sea of fine pebbles, raked into wave formations. One of the most famous is the 'dry-landscape' garden completed in the late 15th century at Ryoanji, a temple in Kyoto.

Early Japanese paintings of landscapes follow the Chinese tradition: magical, hazy, imagined, and based on earlier paintings and poetry rather than observation. Western writers on Japan such as Sir George Sansom and Ruth Benedict have commented that the Japanese traditionally lacked a sense of contrast between the real and the ideal. Perhaps that may be how they are able to blot out the ugly alongside the beautiful, the urban sprawl in

front of the view of Fuji or the sea. There is, however, a clear development from the ideal to the real in the way landscape is depicted.

Tani Bunchō (1763–1840) brought an idealized, Chinese-based tradition of landscape painting from Kyoto and Osaka to Edo. He fused this with Western as well as other Japanese ideas while working for the most powerful patrons, as he himself came from a samurai family. This style is known as Nanga, and it appealed to discontented samurai, a new breed of scholars, monks,

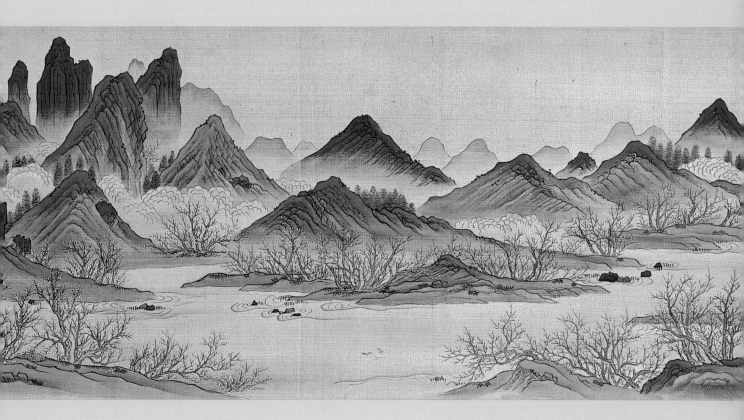

merchants and painters looking for a way out of the conventions imposed from Edo. Other works by Bunchō include ink paintings on typically Chinese subjects such as 'dragon in clouds' and 'summer mountains' (BM). Other artists of this Nanga School include Ikeno Taiga (1723–76), and haiku poet-artists like Yosa Buson (1716–83), Watanabe Kazan (1793–1841) and Tomioku Tessai (1836–1924).

Tani Bunchō (1763–1840), Earthly Paradise of Wuling, handscroll painting. Edo, 1780s.
'What are those blue remembered hills?' asked the poet A. E. Housman, in another context, nostalgically summoning up 'the land of lost content'. In Bunchō's imaginary vision of landscape he follows Chinese conventions: blue and green colours; rounded hills, unlike the craggy ones of the Chinese 'Northern School'; the looped style of the literati painters of the 'Southern School'. His work shows a lack of affectation and an innocent vision of perfection and simplicity that are well suited to the legend he illustrates, of a fisherman who finds paradise on earth.

The contrast is clearly visible between Bunchō's blue hills and the highly original work of Hokusai (1760–1849), most famous of Japanese landscape artists. Hokusai trained as a woodblock-cutter as well as studying with masters of the Kanō and Rimpa schools, notably Katsukawa Shunshō (1726–92).

His adopted name means 'man mad about painting', and he was constantly searching for new forms of expression. In 1820 he started a new cycle of work, styling it his 'year one', although he was already aged sixty by then. In fact, much of his most famous work dates from his seventies, when he came out of semi-retirement because he needed the money. Although his is not an idealized imaginary view of landscape, it is still lyrical in conception, most famously in his enormously influential series of 'Thirty-Six Views of Mount Fuji'. The French composer Claude Debussy chose a version of 'The Great Wave' for the cover of his score of *La Mer*, Manet owned a copy of it, and Van Gogh copied it. More recently Lichtenstein, Warhol and Hockney have all been inspired by Hokusai's prints.

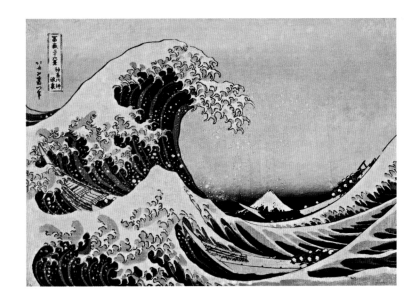

Katsushika Hokusai (1760–1849), Under the wave, off Kanagawa (southwest of Tokyo), colour woodblock print. Edo, 1829–33.

This is arguably the most famous image in Japanese art. Thousands of impressions were made from the original block and countless more from new ones. Hokusai has come a long way from his earlier rather inert depictions of Fuji. The mountain has also changed shape – it is no longer helmet-shaped (as in the sacred paintings of the Muromachi period), but triangular. Hokusai expresses the relation of mountain and sea and the perils of both, out of man's control.

Fuji had last erupted in 1707 and, of course, no one could have known that it would not do so again. Previously Hokusai had separately portrayed Fuji, waves and boats, but here he brings them together for the first time. Technically it is a study in blue and white using Prussian blue pigment, which had just become available cheaply from China and was much longer lasting than earlier blues.

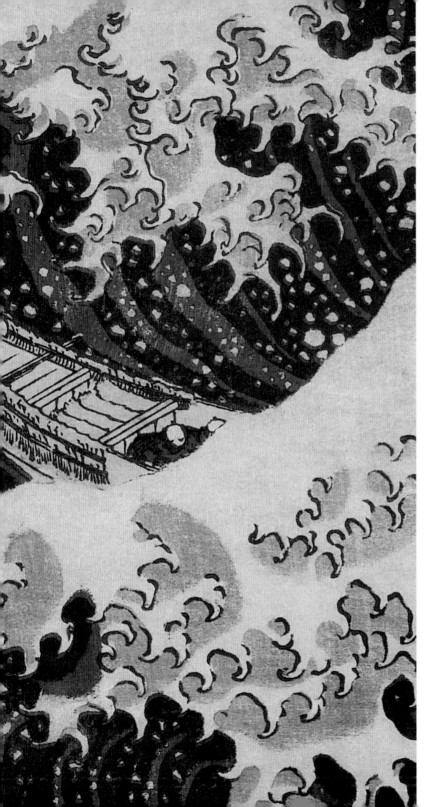

If we read the picture from right to left (as usual with Japanese art) then the wave threatens to engulf us. Experts say the waves are shown very precisely, although to a layman they may appear stylized. They look like claws, animated and reaching out to grasp the fragile boat, which has a protective Shintō torii on its bow (below). It has been suggested that this boat could be bringing back the first tuna of the season to the Tokyo fish market, and that this might explain the abnormally large crew of eight rather than four onboard.

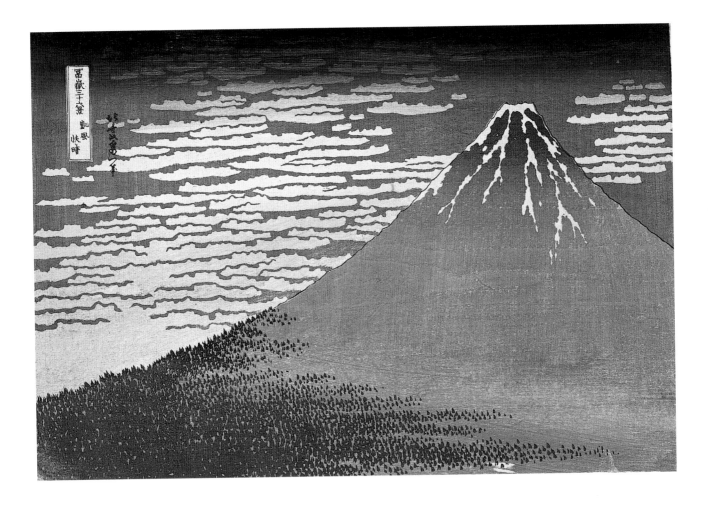

Katsushika Hokusai (1760–1849), South wind, clear sky ('Red Fuji'), colour woodblock print. Edo, 1830–33.

Fuji can appear like this, given the right weather conditions. In fact it can adopt many colours, as the medieval writer Lady Sarashina (b.1008) remembered: 'There is no mountain like it in the world. It has a most unusual shape and seems to have been painted deep blue; its thick cover of unmelting snow gives the impression that the mountain is wearing a white jacket over a dress of deep violet.' Fuji has been sacred since prehistory, and to both Shintō and Buddhist. It is still a challenge for climbers today – now including women (who were previously banned).

**Katsushika Hokusai (1760–1849),
Dragon ascending Mount Fuji, from
'One Hundred Views of Mount Fuji',
woodblock print. Edo, 1835.**

Hokusai created many more views of Fuji,
following the success of the first set. Unusually
the diagonal here is from bottom left. The
composition has an almost Art Nouveau feel to it,
in subtle shades of grey, a tribute to the master

who carved the blocks as well as to the printers.
As often with Japanese prints, it is worth
comparing different impressions to see the
variety in quality.

Dragons inhabit both water and sky and are
messengers of the gods. Natural disasters such
as floods may be explained by dragons,
awakened from their subterranean world. They
also protect the homes of the gods, including Fuji.

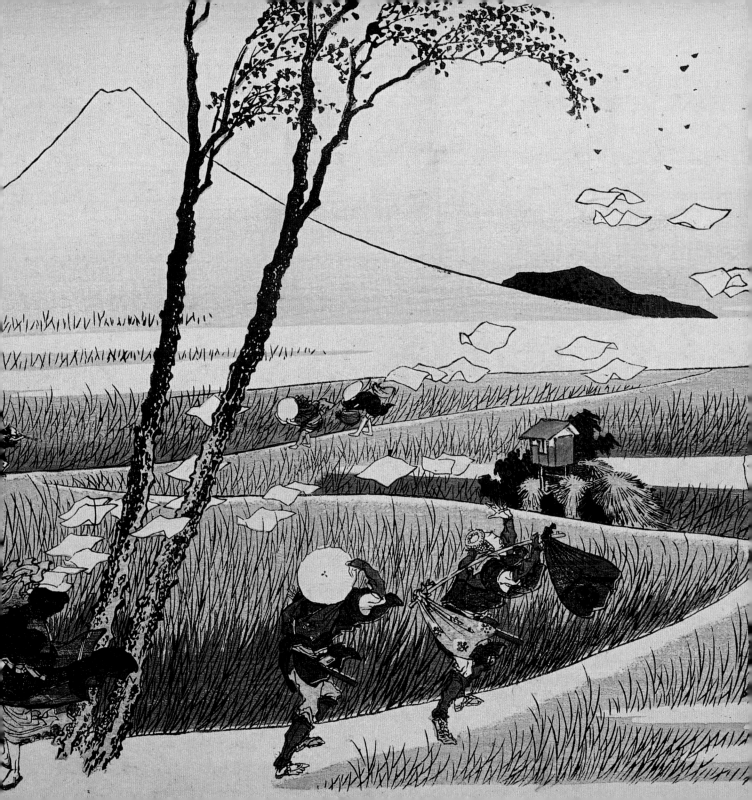

Katsushika Hokusai (1760–1849), Ejiri in Suruga Province, colour woodblock print. Edo, 1830–33.

This superb evocation of a windy day, with a skilful impression of distance created by the swirling path across the fields, inspired the contemporary super-realist artist Jeff Wall to create his own photographic image of a windy day.

Kawamura Bumpō (1779–1821), Scattered fans over waves, from a pair of 6-fold screen paintings. Edo, early 19th century.

Fuji presides everywhere: on fans, ceramics, lacquer and textiles, and today on advertising. Fans are another opportunity for exquisite art in miniature. This is one of thirty-five fans originally pasted on to a pair of screens that were already printed with waves. Bumpō also captured the fun of the Ox Festival in Kyoto (p. 74).

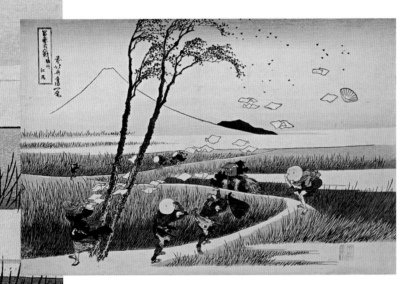

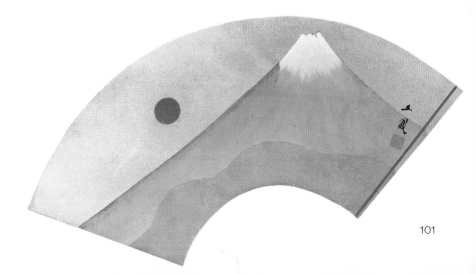

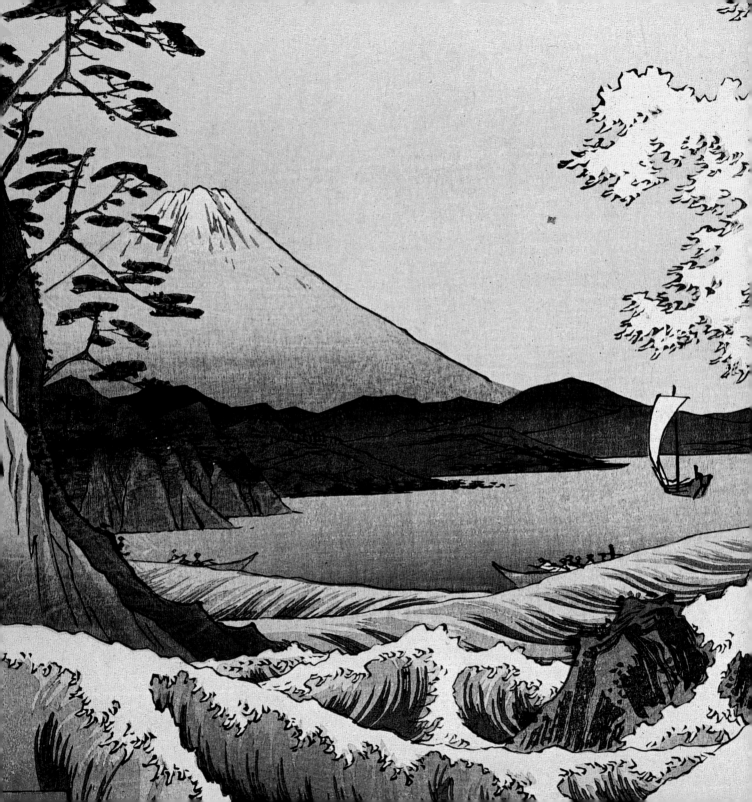

Utagawa Hiroshige (1797–1858), Fuji from the sea at Satta, Suruga Province, from 'Thirty-Six Views of Mount Fuji', colour woodblock print. Edo, 1859.

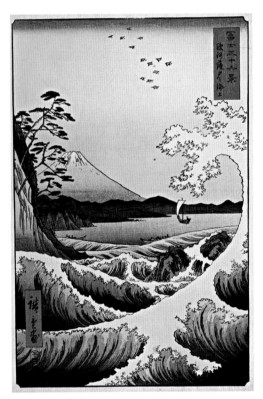

This is Hiroshige's tribute, thirty years later, to Hokusai's 'Great Wave', ten years after Hokusai's death. There is an obvious quote from Hokusai in the wave claws, but this is a more naturalistic and less dramatic composition.

Japan has by now begun to open up to the West, following Commodore Perry's mission in 1853. This is the cusp of both early Meiji and Victorian art – static waves and over-egged detail, with plovers carrying on from the waves. Nature is controlled, made safe and prettified for our gaze.

This is set on the Tōkaidō road, which often hugs the coast and is washed by stormy seas. Hiroshige made an earlier set of the Tōkaidō in the 1830s, which included views of Fuji. Many of his earlier works are more lyrical and atmospheric. This was one of his last works, published posthumously.

Munakata Shiko (1903–75), Kanaya, from 'Munakata's Prints of the Tōkaidō Highway', colour woodblock print. 1964.
This is a tribute to both Hiroshige and Hokusai from Munakata, a highly original and distinctive artist. He has applied colour to both back and

front, in addition to ink from the blocks, so that the thin paper is saturated. In some of his prints Munakata applies colour only from the back. So these are prints without any of the cool elegance or simplicity of Hokusai, but with all the colour density of paintings and textiles.

Munakata was associated with the 'Creative Print' movement, along with Kōshirō Onchi (1891–1955). This group has dominated modern Japanese printmaking. Its members believe that the artist should be involved in every part of the process, not just producing the final drawing for the block cutter. Munakata saw cutting the block as the key part of creating the print, an idea first adopted by Yamamoto Kanae in 1904. Munakata wrote: 'The block is a demon. Something always happens when I take up a chisel and begin to carve … the demon takes over and doesn't pay any attention to the drawing'. He had set out to become a painter, aiming to be 'the Van Gogh of Japan', and was also strongly influenced by Matisse. He became Japan's most famous print artist since Hiroshige and is perhaps best known for his black-and-white images such as the 'Twelve Apostles of Jesus'.

Hagiwara Hideo (b.1913), 'In the Valley Between the Buildings', from 'Thirty-Six Fujis', colour woodblock print. 1986.

This view from the Shinjuku business district of Tokyo could be an urban scene anywhere in the world – until you reach the horizon. Because of modern pollution, Fuji cannot usually be seen from downtown Tokyo, except on New Year's Day when there is little traffic. Hagiwara Hideo works in woodblock, lithograph, etching and stencil. He has created many abstracts using traditional materials such as ground mica, as Onchi had also done.

6

Beauty

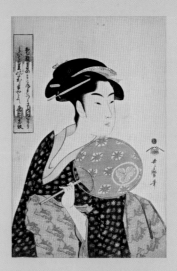

Kitagawa Utamaro (1753–1806), Ohisa of the Takashimaya tea shop, colour woodblock print. Edo, 1792–3.
Ohisa was a celebrated beauty. As it says on her fan: 'Though love and tea are overflowing, neither grows cold'.

Ohisa was the daughter of the owner of a chain of tea shops – their crest of oak leaves is on her fan. Utamaro draws our attention to her neck by twisting her body and therefore her neckline. He suggests the softness of her skin by not depicting her profile with a hard line. Ohisa and other tea-house beauties were also celebrated by other artists such as Shunshō and Harunobu. Clearly this was a successful marketing ploy.

Actors and female beauties were two of the most popular subjects of Ukiyo-e prints. Utamaro (1753–1806) developed a new type of female portrait when banned from illustrating poetry anthologies. In these pictures, called bijinga, female beauty is depicted in a very different way from Western art. Although their faces are apparently mask-like (which reflects their make-up), they are subtly different from one artist to another. This is another example of understatement in Japanese art. There are few aristocratic ladies, mythological goddesses or heroines as in Western art – these are real women, usually earning a living by being beautiful and desirable. There is little nudity, at least not until closer contact with Western art, from the later 19th century onwards. Instead, artists such as Utamaro focus on the woman's neck and back as erogenous zones, a lesson learned by Degas and other Western artists. Some earlier Japanese notions of beauty may now strike us as rather strange: shaved eyebrows, with artificial brows high on the forehead, and blackened teeth, a stylization reproduced for example on Nō masks (see p. 81).

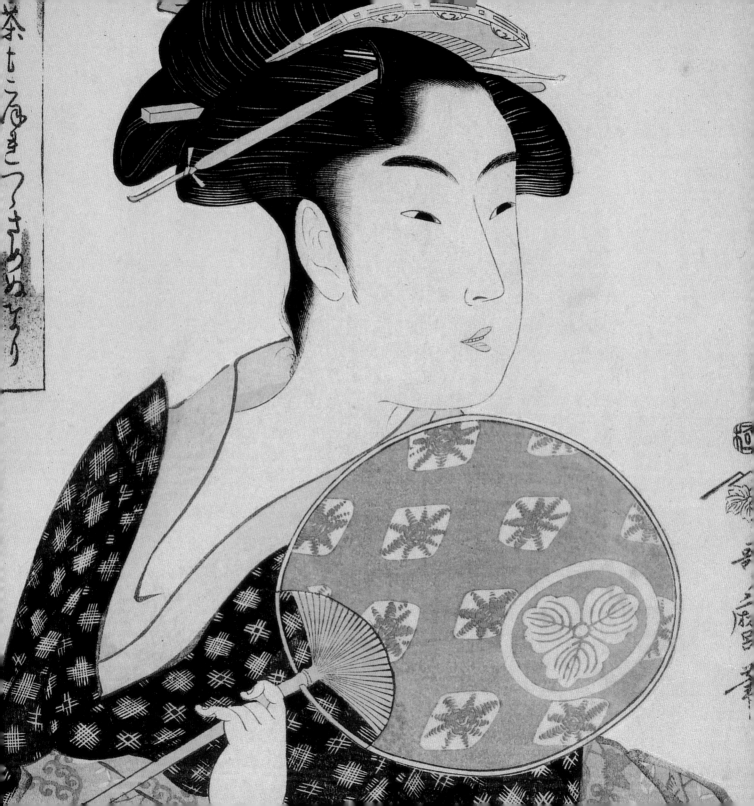

Kitagawa Utamaro (1753–1806), Woman at her morning toilette, hanging scroll painting. Edo, c. 1800.

Careful comparison of Ohisa (p. 107) with this married lady shows differences in age, character and demeanour. We are respectably teased with a glimpse of flesh, again the neck. Colours are muted, but with the coded use of red in the lining of her robe. In Nō dramas, a flash of red in an undergarment may be the height of erotic understatement.

Utamaro has created a statuesque image, made almost monumental by the limited number of objects to give any sense of scale. Our eyes follow the triangular line of the composition from flat basin to hands to face, and then down again following her gaze to the potted morning glory.

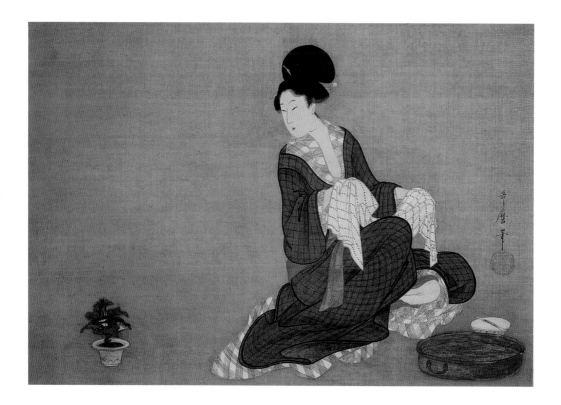

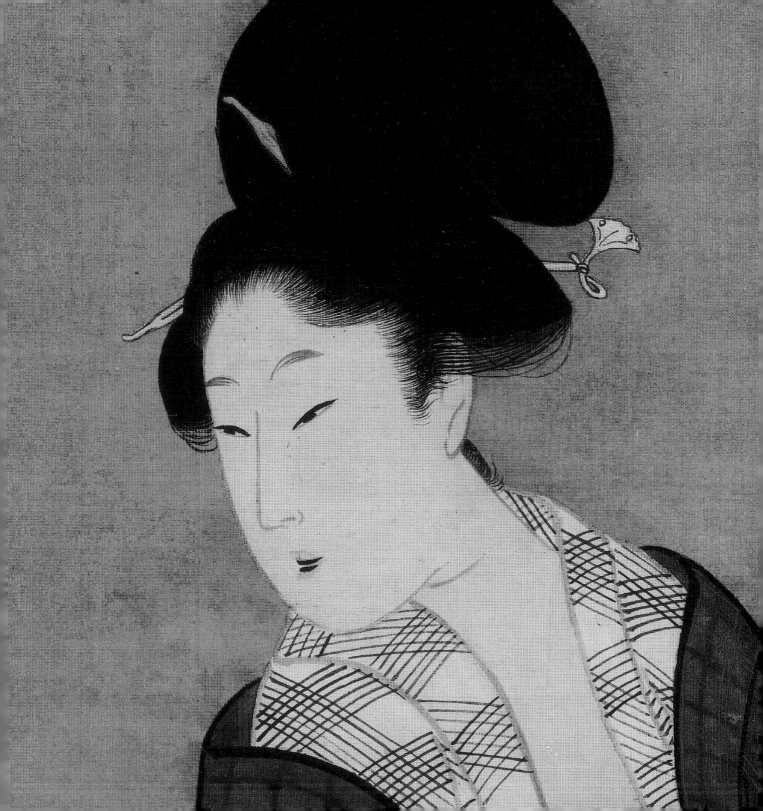

**Kitagawa Utamaro (1753–1806),
Women sewing, triptych of colour
woodblock prints. Edo, *c.* 1795–6.**

These are respectable married women, so the excuse
for a glimpse of their bodies is a sultry summer day.
They are wearing their thinnest layers, which stick to
their skin in the humidity. One or two strands of hair
are out of place – the merest suggestion of
dishevelment is enough. The ladies are handling thin
gauzy material, which is innately sensuous. They are
folding and mending sashes, and peeking through
gauze, which highlights a technical printmaking skill
that we are meant to notice.

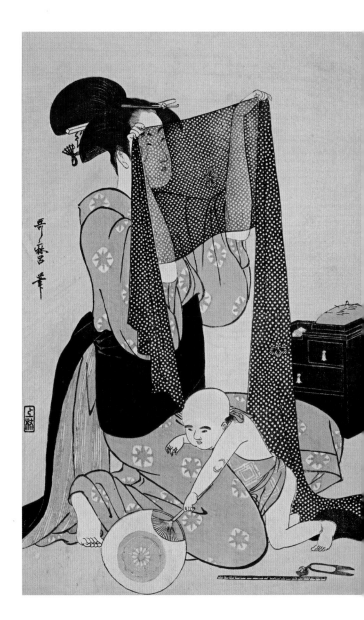

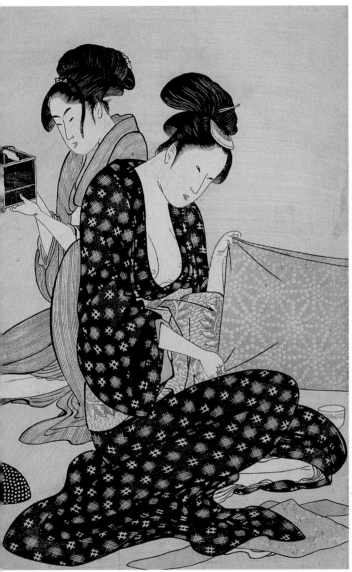
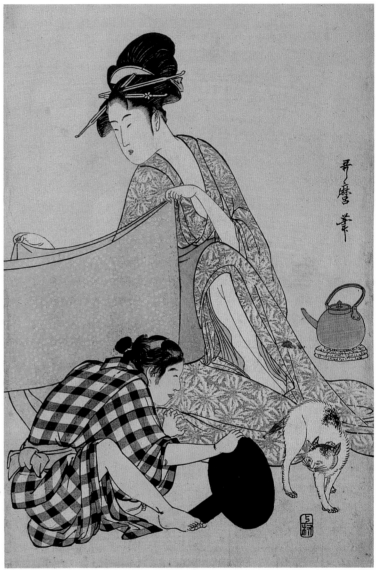

While one young girl looks at insects in their cage, a boy taunts a cat with its image in a mirror. Like Mori's horses (p. 58), this shows a Japanese artist orchestrating a sense of space and movement, flowing across several panels, with two parallel groups, and skilful positioning of objects such as the kettle.

Kanō Tōrin Yoshinobu (1781–1820), Yang Guifei and peonies, triptych of hanging scroll paintings. Edo, early 19th century.

This is a world of overstatement, rich colour and display. It was the central hanging scroll of a triptych that shows opulent Chinese taste in contrast to the understated art of Hokusai or Utamaro. Yang Guifei was the consort of an 8th-century Chinese emperor. Her beauty was famed from poetry that likened her to a peony, considered the most royal of flowers. Yoshinobu was head of a branch of the Kanō School, whose clients included the ruling Tokugawa family of the shogun. Their crest is on the mountings of this painting, which would have suited the lavish tastes of these patrons.

Utagawa Kunisada (1786–1864), Beauty beside a standing lantern, from the series 'Starfrost Contemporary Manners' (1818–20), colour woodblock print.

We are back in the company of Japanese courtesans, here scantily clad in a red silk robe in the dark of night, dressing the lantern wick inside its paper shade. She is caught with a client, unseen behind the screen – perhaps the artist himself? Kunisada conjures atmosphere with a technically very effective evocation of internal lighting.

He was a friend of kabuki actors and designed many kabuki actor prints. He belonged to the Utagawa School, a complicated phenomenon with many shared names. Founded by Toyohara, it included Hiroshige (see p. 102), Kunisada (who was apprenticed from the age of 15), Kuniyoshi (see p. 128) and, at the end of the tradition, Yoshitoshi (see p. 132). Some writers have seen a decline in grace and quality in the depiction of people, beginning with Kunisada.

The two cups on the black lacquer tray (below) hint at the presence of her client, discreetly hidden by the screen.

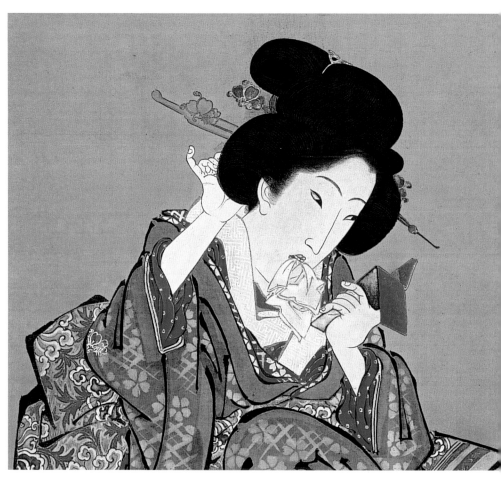

Keisai Eisen (1790–1848), Young woman arranging her hair, hanging scroll painting. Edo, 1820s.

This wealthy young woman appears almost overwhelmed by her kimono and the problems of keeping her hair in place while she corrects her make-up. Eisen shows little of the balance or restraint of earlier artists such as Utamaro.

Interestingly, her neck is covered, but understatement is no longer valued. This rich, overripe style has often been described as decadent and is representative of the last and most highly wrought phase of Edo culture.

Hashiguchi Goyō (1880–1921), Kamisuki, colour woodblock print, 1920.

Modern ideals of beauty are here combined with the zoom lens of the camera and the traditional clothes and erogenous zones of earlier prints. Goyō shows a beauty combing her hair, offering us an informal glimpse of long black hair normally firmly piled in place in three buns. This print is also traditional in technique and materials, with a ground mica background and restrained use of colours. Goyō was a perfectionist and published only a handful of prints (13 designs in all) before his premature death during an epidemic.

The 1920s were a period of some freedom in the arts, which has been called 'a lost dream briefly restored'. For example, Shinsui Ito (1898–1972) created 'A Collection of Today's Beauties' (1929) and '12 New Forms of New Beauty' (1922). Nudes had become acceptable in mainstream Japanese art under the influence of Renoir and Degas as well as Utamaro.

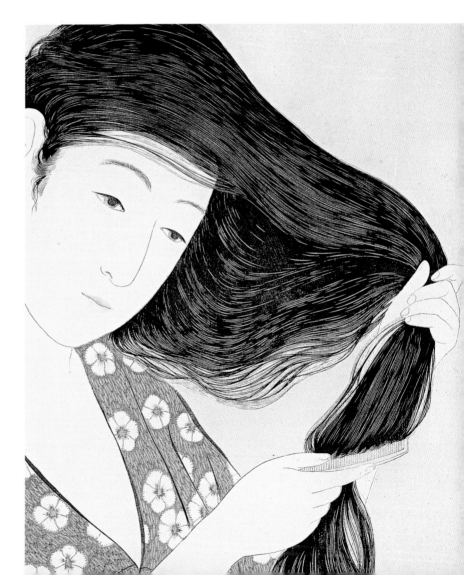

7

Turmoil

Many writers have reflected upon what appears to be a duality in Japanese culture, between the serene (see chapter 2) and the turbulent, whether in religious and secular arts of the past or in aspects of popular culture today, such as manga (graphic novels), film and television. Ian Buruma, for example, describes one Japanese stereotype as 'a gentle people', and then goes on to ask 'how does this soft, meek stereotype (like most stereotypes it has some truth in it) tally with the extreme violence that is such a predominant feature of popular culture?' Today, in pursuit of wa (harmony), the interests of the individual may still be subsumed within the interests of the group. As Buruma puts it, 'Conflict is hidden behind a bland veil of politeness.'

Violence is not a principle of true Shintō or Buddhism, any more than it is of Islam or Christianity, and yet the history of medieval and early modern Japan was extremely violent. Castles and temples were put to the torch, cities perished, clans were wiped out for treachery. The imperial family who introduced Buddhism to Japan was itself brutally suppressed. Agitation, terror, anxiety, violent death are vital to film-makers like Kurosawa and films such as 'Throne of Blood', 'Kagemusha' and 'Ran', which reflect Japanese experience over a far longer period than does the American Western.

This chapter also explores the grotesque, and in particular the depiction of ghosts and the supernatural that can be such a disturbing feature of Japanese art, manga and cinema. Buruma suggests that 'the morbid and sometimes grotesque taste that runs through Japanese culture – and has done for centuries – is a direct result of being made to conform to such a strict and limiting code of normality'.

Composite set of armour, Momoyama and Edo periods, 16th–19th centuries.
The cult of Bushidō, 'the way of the warrior', revolved around swordsmanship, and sword-making is still one of the most highly regarded art forms. This suit of armour shows the impact of the West on this medieval model of warfare. When the Portuguese arrived in Japan in the 16th century, they added a new element to the deadly turmoil of warring clans with the introduction of firearms, so both Japanese armour and castles had to adapt. From that vantage point, the medieval warfare depicted on Edo-period screens reflected a different and long-lost world of individual heroism and chivalry.

119

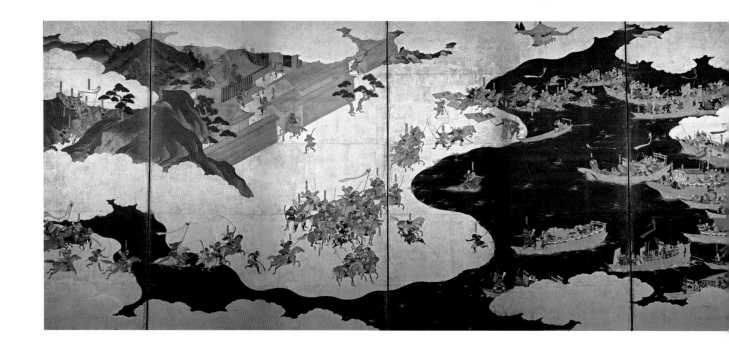

The Battles of Ichinotani, 1184 (right) and Yashima, 1185 (left), pair of 6-fold screen paintings. Edo, early 17th century.

The screens illustrated here record, five centuries later, epic events in medieval Japan from the 'Tale of the Heike'. This imagining of medieval warfare, the work of the Kanō School, was painted at a time when warfare had largely come to an end in Japan. It may be a form of propaganda, identifying the founders of the new Edo military order, the Tokugawa shoguns, with their 12th-century predecessors. Such semi-public art was an opportunity for myth-making, as well as a depiction of heroism in a former supposedly golden age, for latter-day samurai to admire.

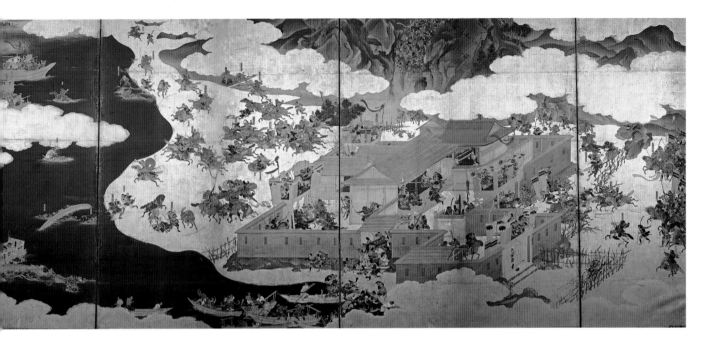

In the battles shown here, the Minamoto clan of Kamakura (white flags) defeated the Taira (Heike) clan (red flags), ended the Gempei Wars and went on to establish the Kamakura shogunate.

Reading from right to left, the dramatic denouement occurs at the point where the two screens (depicting events months apart) meet: marking the end of the courtly Heian era and the beginning of control by the shoguns. Japanese artists have continued to depict these events, and posters of these subjects are still popular today.

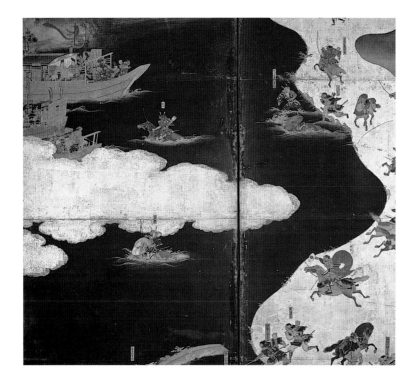

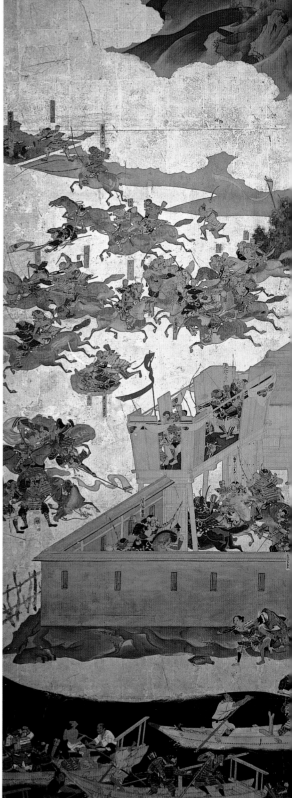

3 This is the famous incident when the Minamoto hero Naozane (red cloak flapping) challenges a retreating Taira warrior (Atsumori, already way out to sea and nearly at the boats) to stand and fight. When Naozane lifts Atsumori's helmet he sees a beautiful young man, not unlike his own son, who begs to be killed. Naozane does so, and then finds a famous flute in Atsumori's baggage – an expression of Heian court finesse. Naozane is so overcome with remorse for killing the young man that he becomes a monk.

2 Panic – attacked from the rear as well! More Minamoto troops cascade from the top of the screen down from a mountain pass, led by Minamoto Yoshitsune, charging like a storm down a cliff thought to be impassable. Meanwhile, at the bottom of the screen, ladies are trying to escape from the fort on the backs of burly men. Everyone is heading for the boats, some of which have already been sunk.

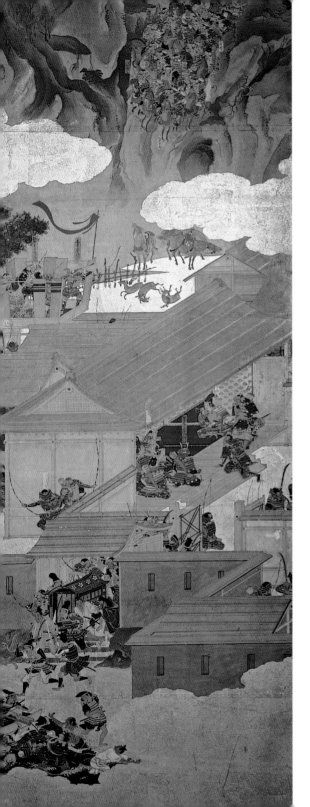

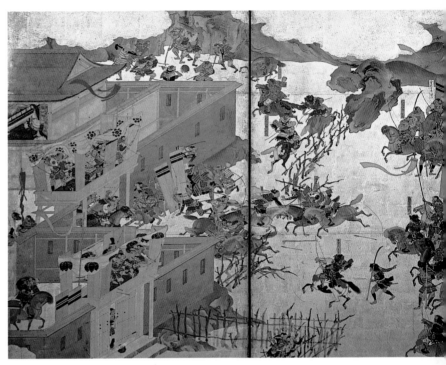

1 The Battle of Ichinotani (1184), near modern Kobe. Mounted samurai with fluttering white pennants erupt on to the plain from the right-hand edge of the screen, the action cut off to heighten the drama. These are the Minamoto troops, attacking the fort of Ichinotani with its new Taira fortifications, which are not portrayed in a realistic manner – we can easily see through them to follow the action.

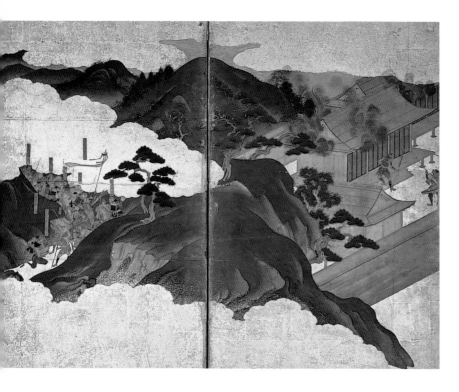

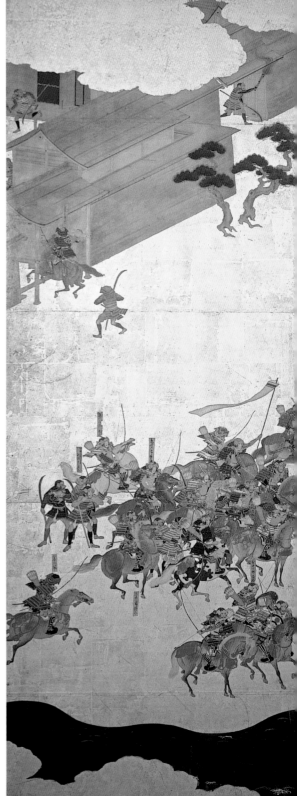

6 The Minamoto army rushes in from the left-hand edge of the screen and sets fire to the Yashima fortress: Yoshitsune, 'the great hero of the battle … shot arrows from horseback like a god; undeterred by gleaming blades, he lunged … he galloped like the wind and fought with a skill that was more than human'.

5 Yoshitsune drives the returning Taira forces back and cuts them down at the sea's edge. Here, in another celebrated moment, the Minamoto warrior Nasu-no-Yoichi (centre right) responds to a challenge and fires an arrow at a fan held by a lady on the prow of a distant ship (p. 125, bottom left).

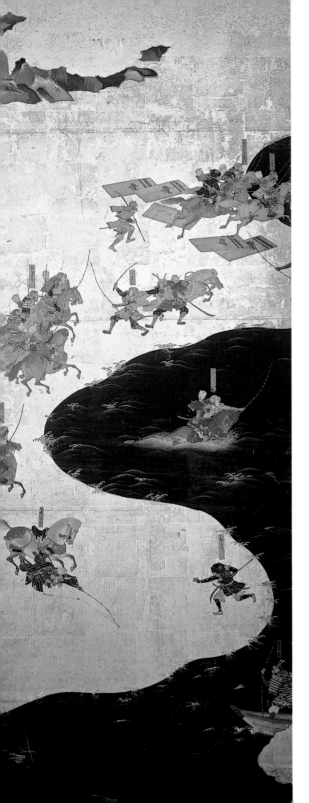

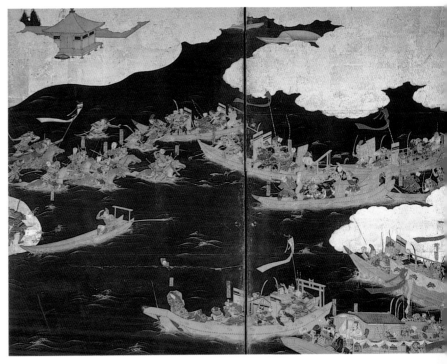

4 The battle of Yashima (1185), then an island covered with pine trees in the sea between Honshu, Japan's main island, and Shikoku. After the defeat at Ichinotani, the Taira retreat to Yashima with the boy emperor and set up a temporary court there. Expecting an attack from the sea, their fleet is ready, but again Yoshitsune surprises them by attacking from behind. Here, after taking to their boats in panic, they have realized that the attacking army is not so large and are returning to face it.

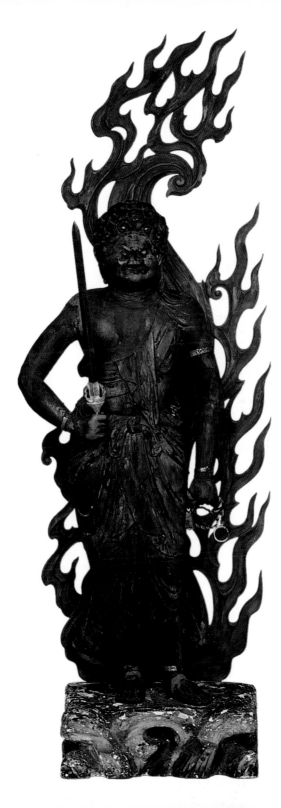

Wooden figure of Fudō Myō-Ō. Heian, 12th century.

Turbulence is a strong theme in religious art. As in Western art, there are also graphic depictions of hells in Buddhist art, a notion brought from China (and a useful tool for social control). Weapons are usually symbolic in Buddhist art: a famous monk once said that 'a master of men must be like the two Buddhist deities Fudō and Aizen … [whose] weapons are not intended for slashing and shooting, but for the purpose of subjugating devils. In their hearts they are compassionate and circumspect.'

This wooden figure predates the military events recalled on the previous screens (pp. 120–25). Here we can see the roots of the Kamakura sculpture to come in the new era, especially in the flames and the bulging eyes and fangs. These ferocious aspects are adopted by the guardian figures at the gates of Buddhist shrines of the Kamakura period. Fudō ('unmoving') appears in the Shingon sect of Buddhism as the enemy of illusion, through which his sword cuts, while his rope ensnares the enemies of enlightenment.

Katsukawa Shunshō (1726–92), The actor Danjūrō V as Fudō Myō-Ō, colour woodblock print. Edo, 1780.

Shunshō, a leading member of the Katsukawa School, was a pioneer in lifelike depictions of kabuki actors. In this popular scene from a kabuki play, the features of a famous actor animate the subject of the sculpture opposite. Fudō was the guardian deity of this long line of actors (see p. 90 for a later member).

An earlier Danjūrō had written: 'The samurai strives to perform brave deeds and to take spoils on the battlefield, and in return receives rewards of wealth and land for his valour. These riches then become his own and can be passed on to his children. The actor strives for success on the stage because he wants the same rewards. But wanting too much is as bad as not wanting enough. One must not strive solely for worldly success.'

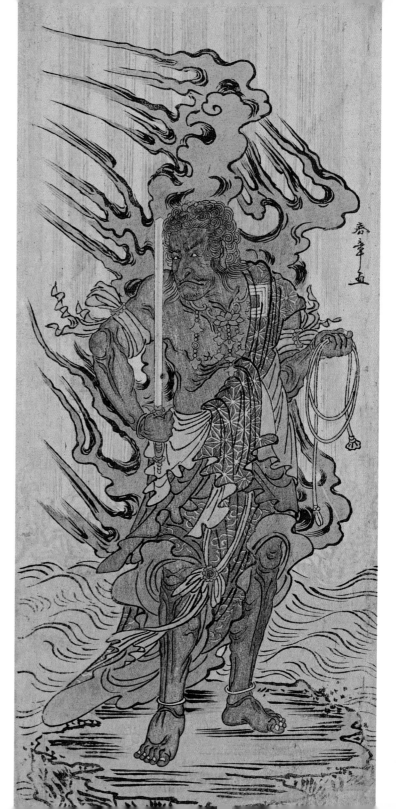

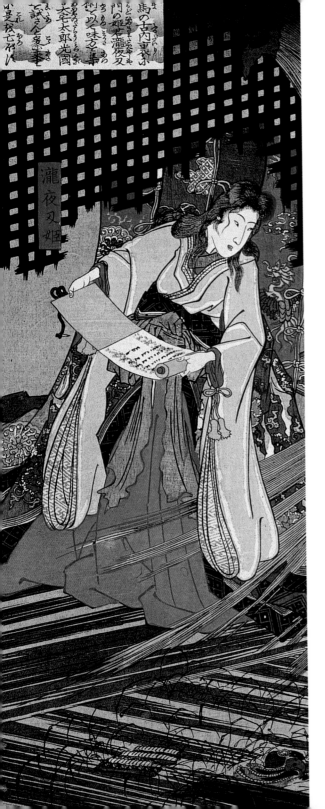

**Utagawa Kuniyoshi (1797–1861),
Princess Takiyasha summons a skeleton
spectre to frighten Mitsukuni, triptych
of colour woodblock prints. Edo, 1844.**
Ghosts and demons have been a popular topic
in Japanese art from at least the Heian period,
for example in 'The Night Parade of 100 Demons'.
At least 8 million kami (spirits of one kind or
another) are believed to inhabit heaven and earth,
in mountains, forest and sea, each usually having
both a gentle and a violent aspect. Hokusai, for
example, illustrated '100 Ghost Tales' (*c.* 1830),
in which many of the spirits are women seeking
revenge for the wrongs inflicted on them.

The master of this genre is Utagawa Kuniyoshi, who has been described as 'the last great master of the Japanese colour print' (though not always well served by his publishers). In Kuniyoshi's work beautiful women are attacked by rampaging giant octopus and carp, or themselves turn into avenging demons from Nō dramas; ghosts lurk on the seabed ready to attack the ships of their former enemies. He depicts bloody suicides, heroes publicly boiled to death in oil, and violent explosions in full technicolour – all highly cinematic before their time.

This bravura design over three sheets combines both ghost and warrior imagery. The story is set in the 10th century and is about one of the Taira clan who has declared himself emperor. He is defeated and killed, providing opportunities for vengeance on both sides. His daughter, a sorceress, lives on in the ruined palace. In this scene she is trying to frighten to death the warrior Mitsukuni, who has been sent by the men who murdered her father to wipe out the rest of her clan. But despite the appearance of this giant skeleton spectre, he survives and eventually subdues the princess. There is a kabuki play on this subject ('the witch princess'), but at this time depictions of kabuki plays and actors were banned.

Kawanabe Kyōsai (1831–89), Female ghost, hanging scroll painting. Meiji, 1871–89.

This scroll painting of a female ghost shows Kyōsai's love of the grotesque. The red of her fangs and the severed neck of her victim, presumably cause and effect, stand out in a composition of shimmering grey.

Kawanabe Kyōsai develops further the work of his master Kuniyoshi, often with a humorous, satirical touch. Kyōsai is known for good reason as the 'Intoxicated Demon of Painting'. He had immense stamina: he could paint a 15-metre theatre curtain in four hours with the help of large amounts of sake, supplied by his patron on a daily basis.

Kyōsai lived through the turbulent transition between the arrival of the 'black dragon' ships of Commodore Perry in 1853, the collapse of the Tokugawa shogunate and the re-establishment of the emperor after seven centuries of military rule. He worked in almost every medium, sketching from life actors, bawdy scenes, frogs and cats, as well as devil women, Shōki the demon queller, Daruma, and vivid hell scenes. His satires got him into trouble with the new Meiji regime – he was imprisoned and given fifty lashes.

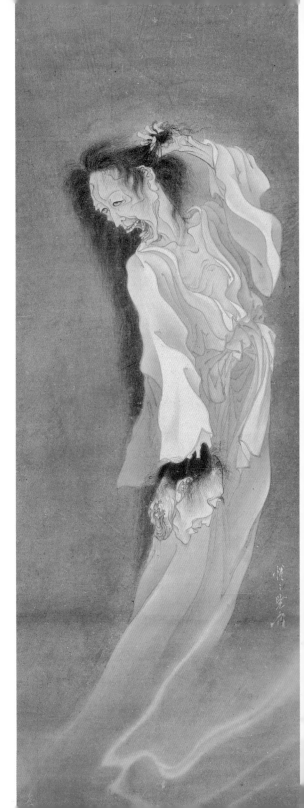

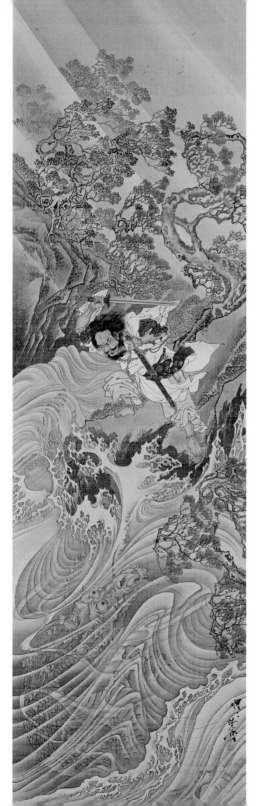

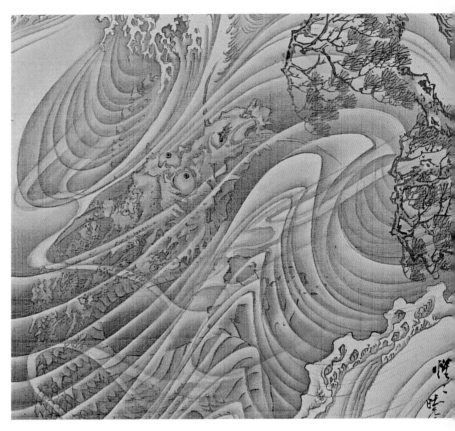

Kawanabe Kyōsai (1831–89), Susano'o no Mikoto subduing the 8-headed serpent, hanging scroll painting. Meiji, c. 1887.

This tour de force has recently been interpreted as an expression of Shintō triumphing over Buddhism. Susano'o, brother of the sun goddess, behaved appallingly, transgressing in every way imaginable, and was banished as a result. Here, however, he is being heroic, perching precariously on a rock at a waterfall, in a torrential gale no doubt whipped up by the serpent he is subduing. As the scroll is unrolled, the cause of all the trouble is revealed.

**Tsukioka Yoshitoshi (1839–92), Yuki ('Snow'),
colour woodblock print. Meiji, 1890.**

Yoshitoshi was the last great master of ghosts
and horror in the woodblock print. As one
commentator has written, Yoshitoshi 'lived
during an age of violent change, and much of his
work is turbulent, impassioned, and disturbing'.
This three-sheet print shows Yoshitoshi at his
virtuoso best, creating atmosphere and drama
within a tightly compressed frame. This is
another kabuki scene, from a play about a priest
who breaks his vow of chastity because of his
infatuation with a beautiful courtesan. Here he
is left alone after her death. As usual we read this
print from the right. His emotional state is
conveyed by his grimace and dishevelled
clothes, as he is attacked by the icy weather.

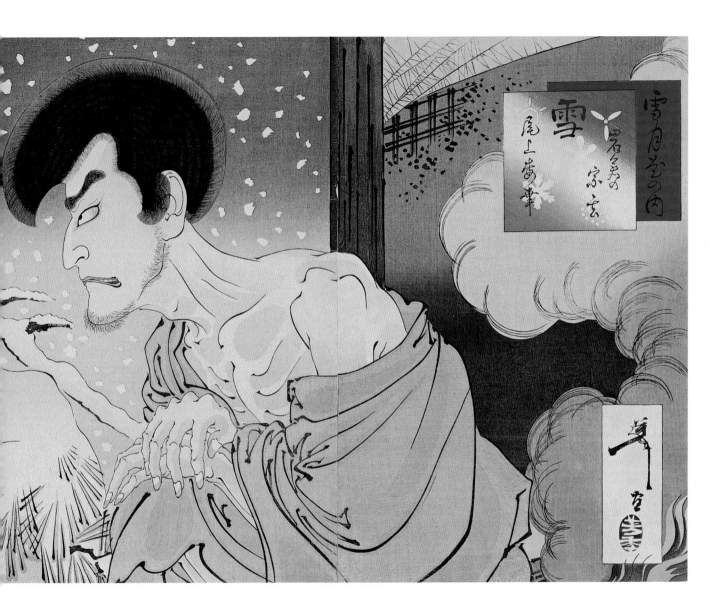

**Hanko Kajita (1870–1919), The Japanese
at the gates of Peking (1894–5), woodblock
print in three sheets, 1900.**

Following 250 years of peace and seclusion,
in the 1850s Japan began to look abroad and
to reach out for power and territory in Asia and
beyond. Artists reflected these foreign
expeditions: the 1894–5 war with China and this
later intervention in the massive Boxer Rebellion
that further destabilized an already weak Chinese
state. Encouraged by these successes, Japan
went on to defeat Russia in the 1904–5 war that
announced to the world Japan's arrival as a
major power.

Kajita trained in the style of the Maruyama-
Shijō School, and this print has many familiar
features: a strong diagonal thrust from the right
across all three sheets; a key figure in motion
seen from the back, drawing us into the action;
mist and cloud eliminating distracting details.
Although this is still very much a print rather than
a photograph, we have come a long way from
the screens at the beginning of this chapter.

8

Further information

FURTHER READING

Japanese art: introductory reading

S. Addiss, *How to Look at Japanese Art*. Abrams, 1996

K. Blood et al, *The Floating World of Ukiyo-e: Shadows, Dreams and Substance*. Abrams & Library of Congress, 2001

Y.-Y. Brown, *Japanese Book Illustration*. British Library, 1988

T. Clark and O. Ueda, *The Actor's Image*. Princeton University Press, 1994

G. Fahr-Becker (ed.), *Japanese Prints*. Taschen, 2002

F. Fischer, *The Arts of Hon'ami Koetsu*. Philadelphia Museum of Art, 2000

M. Forrer, *Hiroshige Prints and Drawings*. Prestel, 1997

M. Forrer, *Hokusai Prints and Drawings*. Prestel, 1991

C. Guth, *Japanese Art of the Edo Period*. Everyman Art Library, Weidenfeld, 1996

C. Hartley, *Prints of the Floating World*. Fitzwilliam Museum & Lund Humphries, 1997

T. Hayashi, M. Nakamura and S. Hayashiya, *Japanese Art and the Tea Ceremony*. Weatherhill & Heibonsha, 1974

J. Hillier, *The Art of the Japanese Book*, 2 vols. Sotheby's, 1987

J. Hillier, *The Japanese Print: A New Approach*. Tuttle, 1975

R. Lane, *Images from the Floating World*. Oxford University Press, 1978

A. Munroe, *Japanese Art since 1945: Scream Against the Sky*. Abrams, 1994

M. Narazaki, *Sharaku: The Enigmatic Ukiyo-e Master*. Kodansha, 1983

L. Roberts, *A Dictionary of Japanese Artists*. Weatherhill, 1976

R. Salter, *Japanese Woodblock Printing*. A. & C. Black, 2001

R. Schaap (ed.), *Heroes and Ghosts: Japanese Prints by Kuniyoshi*. Hotei, 1999

J. Stanley-Baker, *Japanese Art*, 2nd edn. Thames & Hudson, 2000

B. Stewart, *A Guide to Japanese Prints and their Subject Matter*. Dover, 1979

The multi-volume Heibonsha Survey of Japanese Art (Weatherhill & Heibonsha) includes titles on architecture, calligraphy, gardens and costume and the Tea Ceremony, as well as art historical periods and media.

Japanese architecture, crafts and design

J. Allen, *The Designer's Guide to Japanese Patterns*, 3 vols. Thames & Hudson, 1988, new edn 1999

R. Banham and H. Suzuki, *Contemporary Architecture of Japan 1958–1984*. Rizzoli, 1985

B. Bognar, *The New Japanese Architecture*. Rizzoli, 1990

R. Faulkner and A. Jackson, *Japanese Studio Crafts*. Laurence King, 1995

S. Hibi, *Japanese Detail*, 3 vols. Thames & Hudson, 1989

J. Lowe, *Japanese Crafts*. John Murray, 1983

R. Moes, *Mingei: Japanese Folk Art*. Brooklyn Museum & Universe, 1985

H. Oka, *How to Wrap Five More Eggs: Traditional Japanese Packaging*. Weatherhill, 1975

P. Sparke, *Japanese Design*. Michael Joseph, 1987

S. Yanagi, *Mingei, The Living Tradition in Japanese Arts*. Japan Folk Crafts Museum & Kodansha, 1991

Japan past and present

W. G. Beasley, *The Japanese Experience: A Short History of Japan*. Weidenfeld & Nicolson, 1999

H. Bechert and R. Gombrich (eds), *The World of Buddhism*. Thames & Hudson, 1984

R. Benedict, *The Chrysanthemum and the Sword: Patterns of Japanese Culture*. Houghton Mifflin, 1946, new edn 1989

R. Bowring and P. Kornicki (eds), *The Cambridge Encyclopaedia of Japan*. Cambridge University Press, 1993

I. Buruma, *A Japanese Mirror: Heroes and Villains of Japanese Culture*. Penguin, 1985

I. Buruma, *Inventing Japan 1853–1964*. Weidenfeld & Nicolson, 2003

M. Collcutt, M. Jansen and I. Kumakura, *Cultural Atlas of Japan*. Phaidon, 1988

T. Crump, *The Death of an Emperor: Japan at the Crossroads*. Oxford University Press, 1991

T. Hoover, *Zen Culture*. Routledge, 1978

D. Keene (ed.), *Anthology of Japanese Literature to the 19th Century*. Penguin, 1968

A. Kerr, *Lost Japan*. Lonely Planet, 1996

I. Morris, *The World of the Shining Prince: Court Life in Ancient Japan*. Penguin, 1969

E. Reischauer, *The Japanese*. Harvard University Press, 1981

E. Seidensticker, *Low City, High City*. Knopf, 1983

Y. Shimizu (ed.), *Japan: The Shaping of Daimyo Culture*. National Gallery of Art, Washington, DC, 1988

Japanese art and the West

J. Ayers, O. Impey and J. Mallett, *Porcelain for Palaces: The Fashion for Japan in Europe, 1650–1750*. Oriental Ceramics Society, 1990

K. Berger, *Japonisme in Western Painting from Whistler to Matisse*. Cambridge University Press, 1992

C. Feller Ives, *The Great Wave: The Influence of Japanese Woodcuts on French Prints*. Metropolitan Museum, 1974

P. Hardie and M. Conte-Helm, *Japonisme*. Ceolfrith Press, Sunderland, 1986

F. King (ed.), *Lafcadio Hearn: Writings from Japan*. Penguin, 1984

G. Lacambre, *Le Japonisme*. Grand Palais, 1988

B. Leach, *A Potter in Japan*. Faber & Faber, 1960

T. Luke, *Museum Politics: Power Plays at the Exhibition*. University of Minnesota Press, 2002

J. Meek and G. Weisberg, *Japonisme Comes to America: The Japanese Impact on the Graphic Arts*. Abrams, 1990

T. Sato and T. Watanabe, *Japan and Britain: An Aesthetic Dialogue 1850–1930*. Lund Humphries & Barbican Art Gallery & Setagaya Art Museum, 1991

F. Whitford, *Japanese Prints and Western Paintings*. Studio Vista, 1977

S. Wichmann, *Japonisme: The Japanese Influence on Western Art since 1858*. Thames & Hudson, 1981, 2nd edn 1999

A. Yonemura, *Yokohama: Prints from 19th-century Japan*. Smithsonian, 1990

THE BRITISH MUSEUM

British Museum Press publications

S. Asano and T. Clark, *The Passionate Art of Utamaro*, 2 vols. 1995

R. Barker and L. Smith, *Netsuke: The Miniature Sculpture of Japan*. 1976

T. Clark, *100 Views of Mount Fuji*. 2001

T. Clark, *Demon of Painting: The Art of Kawanabe Kyōsai*. 1993

T. Clark, *Ukiyo-e Paintings in the British Museum*. 1992

D. Cobb (ed.), *Haiku*. 2002

N. Coolidge Rousmanière (ed.), *Kazari: Decoration and Display in Japan 15th–19th centuries*. 2003

C. A. Gerstle, *Kabuki Heroes on the Osaka Stage 1780–1830*. 2005

V. Harris, *Netsuke: The Hull Grundy Collection in the British Museum*. 1987

V. Harris, *Shintō: The Sacred Art of Ancient Japan*. 2001

V. Harris and K. Goto (eds), *William Gowland: The Father of Japanese Archaeology*. 2004

A. Powell, *Living Buddhism* (ch. 3). 1989

L. Smith, *Contemporary Japanese Prints*. 1985

L. Smith, *The Japanese Print since 1900*. 1983

L. Smith, *Japanese Prints during the Allied Occupation, 1945–52*. 2002

L. Smith, *Modern Japanese Prints 1912–1989*. 1994

L. Smith, *Nihonga: Traditional Japanese Painting 1900–40*. 1991

L. Smith (ed.), *Ukiyo-e: Images of Unknown Japan*. 1988

L. Smith, V. Harris and T. Clark, *Japanese Art: Masterpieces in the British Museum*. 1990

W. Zwalf (ed.), *Buddhism: Art and Faith*. 1985

NOTE: Exhibition catalogues may include works from other collections.

British Museum collections and website

Many of the books listed above can be consulted in the Paul Hamlyn Library, a free-entry public reference library housed in the Reading Room in the Great Court: see

www.thebritishmuseum.ac.uk/education/libraries/home.html/hamlyn

The Japanese section of the Department of Asia organizes exhibitions in the specially designed Japanese galleries and elsewhere in the Museum, including highlights of the permanent collections and occasional special exhibitions on artists or themes such as kabuki or swords. To study the collection, apply in writing: consult the Department website for further details on

www.thebritishmuseum.ac.uk/asia

The Department of Asia also holds collections of Japanese ethnography. For example, a collecting trip by Sara Pimpaneau in 2001 to acquire tourist souvenirs is available as an online tour on

www.thebritishmuseum.ac.uk/compass

which also includes material on the Ainu native peoples of Japan.

The Coins and Medals Department holds Japanese coins and banknotes. There are displays of money in the HSBC Money Gallery as well as temporary exhibitions.

The Department of Prehistory and Europe holds examples of japonisme and Japanese clocks, which are discussed in L. Smith, V. Harris and T. Clark, *Japanese Art: Masterpieces in the British Museum* (1990).

Most of the images in this book can be accessed digitally via

www.thebritishmuseum.ac.uk/compass

where key objects are described and tours include masks, kabuki, lacquer, etc. Examples of Western japonisme are also included, such as ceramics from the Department of Prehistory and Europe and, from the Department of Prints and Drawings, works showing the impact of woodblock prints on artists such as Pissarro, Degas and Toulouse-Lautrec.

OTHER COLLECTIONS

The Victoria and Albert Museum, London

V&A PUBLICATIONS

J. Earle (ed.), *Japanese Art and Design*. 2000

R. Faulkner, *Masterpieces of Japanese Prints*. 1991

R. Faulkner (ed.), *Tea: East and West*. 2003

J. Hutt, *Japanese Netsuke*. 2003

G. Irvine, *The Japanese Sword*. 2000

A. Jackson, *Japanese Textiles*. 2000

V&A COLLECTIONS AND WEBSITE

In addition to collecting paintings and prints, like the British Museum, the V&A also acquires textiles and decorative arts, including contemporary ceramics.

www.vam.ac.uk shows key objects; then go to 'Access to Images' or 'Asia'.

www.vam.ac.uk/collections/asia/ japan_links
is also very useful generally.

Other collections in the UK and Ireland

Bath, Museum of East Asian Art: www.meaa.org.uk

Birmingham: www.bmag.org.uk

Blackburn: www.blackburn.gov.uk

Bournemouth: www.russell-cotes.bournemouth.gov.uk

Bradford: www.bradfordmuseums.org

Brighton: museums@brighton-hove.gov.uk

Bristol: www.Bristol-city.gov.uk/museums

Cambridge, Fitzwilliam Museum: www.fitzmuseum.cam.ac.uk

www.fitzmuseum.cam.ac.uk/pharos/ sections/making_art/index_japan
shows how a Japanese print is made.

www.fitzmuseum.cam.ac.uk/gallery/japan
looks at Kunisada and kabuki.

Cardiff: www.nmgw.ac.uk/nmgc

Chiddingstone Castle, Kent: www.chiddingstone-castle.org.uk

Dublin, Chester Beatty Library and National Museum:
www.cbl.ie
www.museum.ie

Durham: Oriental.Museum@durham.ac.uk

Edinburgh: www.nms.ac.uk

Glasgow, Kelvingrove, St Mungo's, Burrell Collection: www.glasgowmuseums.com

Leeds, Royal Armouries: www.armouries.org.uk

Liverpool: www.liverpoolmuseums.org.uk

London, Horniman Museum: www.horniman.ac.uk

Maidstone: www.museum.maidstone.gov.uk

Manchester:
www.man.ac.uk/museum
www.whitworth.man.ac.uk
www.manchestergalleries.org/index.html

Newcastle and Tyneside: www.twmuseums.org.uk

Oxford, Ashmolean: www.ashmol.ox.ac.uk; Pitt-Rivers: www.prm.ox.ac.uk/japan

Snowshill Manor: www.nationaltrust.org.uk/places/ snowshillmanor

Stamford, Burghley House: www.burghley.co.uk

For full details of collections in country houses as well as museums and galleries see: G. Irvine, *Japanese Art Collections in the UK*. The Japan Society & Hotei, 2004.

OTHER COLLECTIONS IN EUROPE, THE USA AND JAPAN

Europe

Belgium, Musées Royaux d'Art et d'Histoire, Brussels: www.kmkg-mrah.be

France, Musée Guimet, Paris: www.museeguimet.fr

Germany, Museum für Ostasiatische Kunst: www.smb.spk-berlin.de

Netherlands, National Museum of Ethnology, Leiden: www.rmv.nl

Poland, National Museum, Krakow: www.krakow-info.com/museums

Portugal, Lisbon:
www.mnarteantiga-ipmuseus.pt
www.gulbenkian.pt; www.foriente.pt

Sweden, World Culture Museum,
Gothenburg: www.varldskulturmuseet.se

See also the series of publications:
T. Kobayashi (ed.), *Japanese Art: The Great European Collections*. Kodansha

USA

Art Institute of Chicago: www.artic.edu/

Asian Art Museum, San Francisco:
www.asianart.org; www.search.famsf.org

Asia Society of New York:
www.asiasociety.org

Cleveland Museum of Art:
www.clevelandart.org

Honolulu Academy of Arts:
www.honoluluacademy.org

Library of Congress:
www.loc.gov/exhibits/ukiyo-e/japan

Los Angeles County Museum of Art:
www.lacma.org

Metropolitan Museum, New York:
www.metmuseum.org

Museum of Fine Arts, Boston:
www.mfa.org

Nelson-Atkins Museum, Kansas City:
www.nelson-atkins.org

New York Public Library: www.nypl.org

Philadelphia Museum of Art:
www.philamuseum.org

Sackler Freer Gallery, Smithsonian,
Washington, DC: www.asia.si.edu/

See also the website:
www.artcyclopedia.com

Japan

Edo-Tokyo Museum:
www.edo-tokyomuseum.or.jp

Haniwa Museum, Narita:
www.city.narita.chiba.jp

Kyoto National Museum:
www.kyohaku.go.jp

Tokyo National Museum: www.tnm.go.jp

Collections in Japan can be traced via
www.emuseum.jp
and
www.dnp.co.jp/museum/

Useful general websites
on Japan include:

www.jguide.stanford.edu

www.japan-guide.com/

Bridge to Japan:
www.jlgweb.org.uk/btj

www.vam.ac.uk/collections/asia/
japan_links

Glossary

Amida Buddha ('Infinite Light') presides over the Western Paradise.

Arita Centre of porcelain production on western side of Kyūshū Island.

aware Melancholy sense of transience, typical of Heian courtly culture.

bijinga Pictures of beautiful women.

bushidō 'Way of the Warrior', loyalty to one's lord.

daimyō Samurai governor of a domain.

Edo period 1600–1868; city became modern Tokyo.

fusuma-e Paper sliding door on wooden frame, decorated with paintings.

geisha Professional entertainer, usually female, particularly at parties in the pleasure quarters.

haniwa Pottery figures for Kofun-period burials.

Heian period 794–1185, with capital at Kyoto.

Imari General name for porcelain exported through port of Imari on Kyūshū Island.

inrō Medicine or seal container suspended from sash of kimono, usually lacquered wood.

Jōmon period *c*. 12,500–300 BC.

kabuki Popular theatre of urban Japan, in which men play all the parts.

Kakiemon Dynasty of potters; decoration uses distinctive persimmon (*kaki*) red.

Kamakura period 1185–1333; city south of Tokyo, seat of the first shoguns.

kami Shintō deity or spirit.

Kanga Chinese-style landscape paintings.

kazari A love of decoration.

Kofun period 4th–6th centuries AD.

makie 'Sprinkled pictures' – lacquer decorated with gold or other dust.

manga Originally books of black-and-white sketches, now graphic novels.

Meiji period 1868–1912.

mingei Folk crafts.

Momoyama period 1573–1600.

Muromachi period 1333–1573.

Nanga 'Southern painting', Chinese-influenced ink-painting style.

netsuke Decorative toggle attached to the sash, worn at the waist.

Nihonga Traditional Japanese-style painting school dating from the late 19th century.

Nō Stylized medieval form of courtly dance drama with masks, influenced by Zen.

raku Hand-built, low-fired ceramic with high lead content in the glaze.

Rimpa 18th–19th-century school of painting named after Ogata Kōrin (1658–1716).

samurai Hereditary military class, specifically warriors of rank in the service of the shogun and daimyō.

seppuku Traditional suicide with sword.

shamisen Three-stringed musical instrument.

Shingon Esoteric Buddhist sect.

Shintō 'Way of the Gods', native religion of Japan.

shogun Military rulers of Japan, 1185–1868.

Shunga Erotic pictures ('springtime pictures').

surimono Privately published prints, used as gifts or announcements.

torii Gateway to a Shintō shrine.

Ukiyo-e Paintings and prints of the 'Floating World' of urban pleasures, 17th–19th centuries.

wabi Restrained good taste, central aesthetic concept of the Tea Ceremony.

Yoshiwara Government-licensed pleasure district in the city of Edo.

Zen Buddhism Major Chinese tradition that has flourished in Japan since the 13th century.

Sources of quotations in the text

Preface

T. Clark, *Ukiyo-e Paintings in the British Museum*: no. 132.

H. Oka, *How to Wrap Five More Eggs: Traditional Japanese Packaging*.

Chapter 1

S. Yanagi, Introduction, in B. Leach, *A Potter's Book*. Faber & Faber, 1940, reissued 1976: p. xvii.

Chapter 2

Hui-k'ai, 'The Gateless Barrier', quoted in P. Morgan, *Dictionary of World Religions: Buddhism*. Batsford, 1987: pp. 13–14.

Chapter 3

Bashō, in D. Keene (ed.), *Anthology of Japanese Literature to the 19th Century*: p. 348.

Chiyo-ni (1703–75), Haiku, in D. Cobb (ed.), *Haiku*: p. 14.

Chapter 4

Asai Ryōi, *Tales of the Floating World*, *c.* 1661, in R. Lane, *Images from the Floating World*: p. 11.

O. Statler, *All-Japan: The Catalogue of Everything Japanese*. Quill, 1984: p. 197.

Kato Eibian, *My Robe*, 1820, quoted in C. Segawa Seigle, *Yoshiwara: The Glittering World of the Japanese Courtesan*. University of Hawaii Press, 1993.

Chapter 5

Lady Sarashina, *As I Crossed a Bridge of Dreams*. I. Morris (trans.), Penguin, 1975: p. 39.

Chapter 7

I. Buruma, *A Japanese Mirror: Heroes and Villains of Japanese Culture*: pp. 219, 221, 225.

Y. Shimizu (ed.), *Japan: The Shaping of Daimyo Culture*: p. 18.

L. Kominz, *The Stars Who Created Kabuki*. Kodansha, 1997.

S. Addiss, *How to Look at Japanese Art*: p. 109.

British Museum registration numbers

Chapter 1
FB5
JA JP ADD 943
JA 1907.5-31.204
JA 1924.3-27.9(1)
JA F2210; JA 2003.3-19.4
JA 1985.2-25.2
JA 1974.2-26.81

Chapter 2
JA 1945.4-19.1
JA 1886.3-22.7
JA JP 362
JA 1885.12-27.98
JA 1891.9-5.20
OA 1981.12-10.277
JA 1992.5-25.91
JA F1891
JP ADD 1110

Chapter 3
JA 1945.11-1.44
JA 1974.5-13.13a,b
JA JP ADD 129–132
JA 1982.10-21.1, JP ADD 723
JA F1283+
JA F478
JA 1912.10-12.20
JA 1946.10-12.1a–c
JA JP ADD 880
JA JP 2500
JA JP ADD 79
JA 1974.5-13.8a,b
JA F782

Chapter 4
JA JP 1379–80
JA JP ADD 639
JA JIB 515A
JA 1979.3-5.146
OA+133.6
OA+7105
JA 1907.5-31.490(1–3)
JA 1945.11-1.49
JA 1909.6-18.53
JA 1906.12-20.462
JA 1906.12-20.1342
JA 1986.10-29.3 (reproduced
 by courtesy of the artist)

Chapter 5
JA JP ADD 608
JA 1937.7-10.147
JA 1906.12-20.525
JA (JH 454)
JA 1907.5-31.545
JA 1902.2-12.396(25)
JA JP ADD 1146
JA 1981.7-30.12
JA 2000.3-29.3 (reproduced
 by courtesy of the artist)

Chapter 6
JA 1927.6-13.6
JA JP ADD 380
JA 1912.4-16.220
JA JP 788–90
JA 1942.1-24.15
JA JP ADD 703
JA 1930.9-10.1

Chapter 7
JA OA+13545
JA JP ADD 324
JA 1961.2-20.1
JA 1902.1-12.202
JA 1915.8-23.915–16
JA JP ADD 1096
JA JP ADD 397
JA 1989.11-1.01(1–3)
JA 1946.2-9.90

Index